The Practical Guide to
DIGITAL IMAGING
MASTERING THE TERMS, TECHNOLOGIES, AND TECHNIQUES

MICHELLE PERKINS

AMHERST MEDIA, INC. □ BUFFALO, NY

To Paul. You are flapjack.

Published by:
Amherst Media, Inc.
P.O. Box 586
Buffalo, N.Y. 14226
Fax: 716-874-4508
www.AmherstMedia.com

Publisher: Craig Alesse
Assistant Editor: Barbara A. Lynch-Johnt

ISBN: 1-58428-150-2
Library of Congress Card Catalog Number: 2004101353

Printed in Korea.
10 9 8 7 6 5 4 3 2 1

Notice of Disclaimer: The information contained in this book is based on the author's experience and opinions. The author and publisher will not be held liable for the use or misuse of the information in this book.

Table of Contents

Table of Contents

Getting Started

The digital revolution has, for a lot of people, put the fun back in photography. By increasing control and reducing disappointing surprises (Mom's eyes were closed!), digital has made it easier for everyone to create memorable images.

INTRODUCTION

Whether you just like to snap photos of your kids or aspire to be the next Ansel Adams, digital imaging will help you create images that inspire!

This book is for anyone who wants to learn more about digital imaging and how to make the most of this new technology. Whether you are shopping for your first digital camera, want to stick to film but still use digital imaging software to retouch your images, or have been using digital for a while but feel you need a stronger grasp of the concepts to maximize your results, you'll find information here that will fit the bill.

In the first chapter of this book, we'll look at the basics—concepts that you need to understand thoroughly to begin purchasing or using your digital-imaging hardware and software. You may want to refer back to this chapter periodically.

Next, we'll look at digital cameras and learn about the features that set models apart, as well as how these different features can improve your images. In this chapter you'll find the information you need if you're planning to purchase a digital camera—or if you already own one and want to learn how to make better use of it. Because new digital cameras are being introduced every day, at the end of the chapter you'll also find some helpful resources for evaluating the fea-

tures of individual models, as well as for getting reviews from digital camera users on what they like and don't like about specific cameras or features.

In the chapter that follows, we'll examine shooting techniques, looking at some of the great advantages of shooting digital—and noting a few common problems to watch out for!

Even if you want to continue shooting your images on film, you can still use digital imaging—you'll just need to digitize your film images using a scanner. To this end, we'll look at scanners and discuss how they can be most effectively used. This will also come in handy for those who *do* shoot digitally but have decades of negatives and prints sitting around the house—old family photos that certainly shouldn't be written off just because digital imaging has come to town. In fact, now is the perfect time to drag out those photos and fix damaged areas, crop them, remove blemishes, and take care of anything that might have made you store them in a drawer instead of displaying them on your walls.

Of course, without a computer, digital imaging doesn't reach its full potential. Therefore, setting up an effective system for digital imaging is also cov-

ered—along with some useful gadgets that make the experience of digital imaging even nicer!

With your computer set up, you'll be ready to move on to using digital imaging software. Options for every price point (from amateur to pro) are covered, and step-by-step techniques are included for many common operations.

Next, you'll learn how to output your images, with techniques for home and commercial printing—and some advice on the costs and quality issues involved.

Finally, tips for building a safe and convenient digital workflow are presented. These will help you ensure that your images are protected, well organized, and easy to access—so you'll never need to spend hours looking for a lost digital file (as we've all probably done with a misplaced negative at one time or another).

Using This Book

As you flip through this book, you'll notice that the chapters are divided into two-page lessons. These are designed to take you from one concept to the next in a logical order, with each lesson building on the terms and concepts discussed in previous lessons and chapters. As you progress, however, you may want to skip around and read the topics that are of most interest to you or apply to a specific issue that you have. For example, if you just want to print an image without retouching or cropping it, you can skip from the chapters on digital cameras and computers right to the one on printing.

With digital imaging software, it only takes a few seconds to add interesting effects to your images.

EASIER (AND HARDER)

Once you buy a digital camera, all your troubles are over and you'll never take a single bad picture again, right? Well, not exactly. Digital photography has its own challenges . . .

As photographers, whether professional or amateur, we have the distinct pleasure of being involved in photography at a time when the art form is undergoing its biggest changes in decades. Not since the advent of color photography has there been such a revolution in the field!

Digital imaging has made it possible to take total control of your photography and create images that were previously either terribly time-consuming or flat-out impossible. You can shoot hundreds of frames without having to pay a cent for film or developing—and sharing each dazzling new creation with your whole family is as easy as sending out an e-mail.

As with anything else, however, new privileges come with new responsibilities. The following are some of the issues to consider.

New Challenges

With film, you shot your pictures and dropped off your film at the lab. If a print came out looking terrible, the lab probably reprinted it at no charge (unless the negative was really badly exposed; then you were just plain out of luck). With digital, on the other hand, you are (at least to some extent) your own photo lab—you are personally responsible for making sure that your images look just right. Whether you print your images at home on an inkjet printer or take them to a lab, how you handle the files will determine how good your prints will look. If digital prints come out poorly, it's almost always because the file being printed isn't right in some way (it could be too dark, too low in contrast, have a color cast, etc.).

When shooting digitally, you'll probably find that you shoot a lot more pictures—maybe several times more than you would have on film. Once you get home, though, you're going to somehow need to archive all of these images so you can find them later. That can be a bit of a time-consuming task.

Oh—and what happens when you (or your less technically savvy spouse or friend) accidentally deletes a folder full of photos from your hard drive? Ouch.

But relax . . . the news is definitely not all bad!

New Advantages

So, yes, you are your own lab. The good news is that once you figure out how to adjust your photos so they print well,

you should get great results with virtual-ly every print. I don't know about you, but that's something I never quite got from my film lab. (If your film lab was great, though, see if they can print your digital files so you can continue to enjoy their expertise!)

On a related note, there's another *huge* advantage to digital: retouching. Almost all images require at least a little retouching to look their best—whether it's concealing a blemish, removing a lamppost that protrudes from the top of a subject's head, or even cropping out your ex-boyfriend. When they are frozen in time, these annoyances can really stand out like a sore thumb. With film, it just wasn't financially feasible for most people to have their everyday images retouched. With digital, there's no rea-son you have to live with anything in your image that you don't want to be there. Even if you only spend five min-utes, just this tiny bit of retouching can

make a huge difference and really polish your image.

Now, let's address the thousands of images you're going to shoot. Yes, they present challenges for archiving, but we'll deal with that on pages 110–11. What's more important, though, is that they give you more chances to get great images—the odds are with you! (And you can always delete the images that don't work out!)

Last but not least, digital gives you instant results. You know right away that you did or did not get the shot. If you did, you can relax; if you didn't, you can reshoot before the subject walks away. Knowing you got the shot is probably the best advantage of digital.

In the end, most people find that the instant results and increased control of making the change to digital are well worth their while—and with a little knowledge, that even the challenges are quite manageable.

Unlike film, using digital makes it easy to ensure you've achieved the result you wanted *before* you leave the scene.

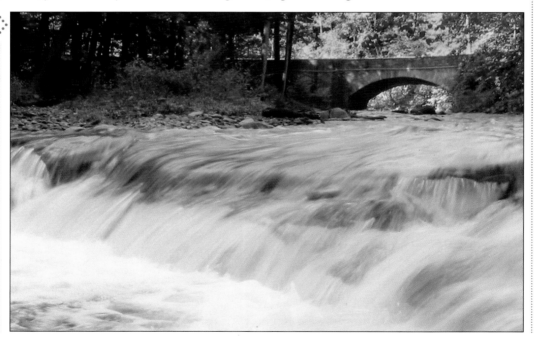

The Basics

In this chapter, you'll learn the basic concepts of digital imaging—the terms and ideas you need to get started. These are things you'll need to know as you work on every image, so take the time to read each section thoroughly.

RESOLUTION, PART 1

Resolution is one of the concepts that people who are new to digital imaging usually find the most confusing. Fortunately, it's not as tricky as it might initially seem.

Digital images are made up of dots called pixels. The resolution of an image tells us how close together those dots are (the dots per inch—referred to as the "dpi" of an image). Images with dots that are close together are said to have a "high" resolution (a high number of dots per inch). Images with dots that are far apart are said to have a "low" resolution.

A (Mostly) Fixed Total

The total number of pixels in an image is, for the most part, a fixed value. (See pages 12–13 for how to change the number of dots in an image when need-ed.) You can think of the data in an image as being like a cup full of coffee. When the coffee is in the cup, it has a small surface area, but it's pretty deep. If you poured the coffee out on the floor, the exact same amount would cover a lot more area, but it would also be much shallower. (*Note:* It's really better to just drink your coffee, but if you must try this experiment for yourself, be sure to have plenty of paper towels on hand.)

With a digital file that has, let's say, 4000 total pixels, the same principle applies. If you used those pixels to create an image that was only 1"x1", the pixels would be quite close together (the

The resolution your image needs to be depends on how you want to use it. The image on the left is at 300dpi, perfect for printing in a book. The image on the right is at 72dpi. This would look just fine on a web site, but its resolution is too low to look good in print. For more on this, see pages 12–13.

WHICH IS BIGGER?

Which is bigger, the image on the left or the one on the right? Actually, it all depends on how you look at it. The image on the right definitely covers more space, but both images are made up of the same number of identical dots. In the image on

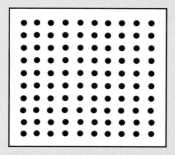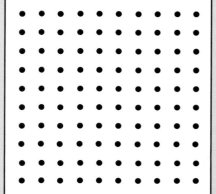

the left, the dots are tightly packed, giving it a high resolution (a high number of dots per inch). In the image on the right, the dots are far apart, giving it a low resolution (low number of dots per inch). In the digital world, how much "space" an image covers makes very little difference. What counts is how many dots (pixels) it is made of. How many pixels your image should have is determined by what you want to do with it.

equivalent of the full cup of coffee). If you made an image that was 12"x12", that limited number of pixels would have to spread out quite a bit in order to cover the larger area. As a result, the resolution would be quite a bit lower (the equivalent of the spilled cup of coffee).

So Why Should I Care?

The resolution of an image, to a great degree, determines the apparent quality of the image. High-resolution images tend to look clear and sharp—more like photographs. Low-resolution images tend to look somewhat grainy, speckled, and blurry.

This is why, when digital cameras are advertised, one of the first specifications that you'll see listed for each model is the size of the file it is capable of creating. This is usually listed in megapixels (see pages 20–21 for more on this), but you may also see it listed as the total

pixel dimensions ("640x720 pixels" for instance). The larger the file, the more dots you'll have to work with when creating your images.

Does this mean you should always use the highest resolution possible? Well, no. The more dots in an image, the more the computer has to remember and move around every time you ask it to do something with those dots. This means it will take longer for the image to open, and performing operations on it will be slower. Because it is bigger, you'll also need more space on your hard drive to store it—and it will take longer to upload or download online.

What pixels give you is possibilities—that's why more is usually better in a digital camera. More pixels mean you can make bigger prints (see pages 20–21) or crop the image more dramatically to improve the composition (see pages 84–85).

RESOLUTION, PART 2

Web sites, posters, framed prints, t-shirts, books—there's no end to the ways in which you might want to use your digital images! But how do you select the proper resolution for each project?

So, what should the resolution be? The answer is: only as high as it has to be. The precise number will be determined by how you will use the image.

Which Resolution is Right?

If you want to use an image on your web page, you'll select a relatively low resolution—probably 72dpi. This is all that is needed to create an acceptably sharp image on a monitor. Anything more wouldn't make the image look any better and would increase the time the image takes to load (and, remember, the majority of Internet users still rely on slower dial-up connections!).

If you want to generate a photo-quality print on your inkjet printer, you may want to create a file as large as 700dpi. Check the manual that came with your printer to determine the resolutions recommended for its various print settings.

If you'll be having someone else (like a photo lab) print your image, ask them what they recommend. For more on this, see page 105.

Changing Resolution

Most digital imaging software will allow you to change the resolution of an image. As nice as this sounds, though, it really doesn't take the place of proper planning.

Most software does a good job of moving around existing dots (making them closer together or farther apart), and many applications are even pretty skilled at removing dots (reducing resolution). What they don't do very well is allow you to turn 50 dots into 500 dots. If you ask your software to do this, the program will have to guess where to put these dots and what they should look like. Invariably, it won't guess 100 percent successfully, and your resulting image will appear blurry.

In a pinch, you might be able to get away with increasing the resolution by 25 percent—but any more than this and you'll probably not like the results.

Now, sooner or later, this is going to cause you a big headache—you'll desperately want to make a huge poster and just not have the dots you need. Trust me—every digital imager has been there. It's such a common problem, in fact, that software has been designed specifically to cope with the problem.

Genuine Fractals (www.lizardtech. com) is the granddaddy of image-enlargement software and the one that

photographers are probably most familiar with. Using some clever math, it provides results that are quite satisfactory.

From Extensis (www.extensis.com), pxl SmartScale permits images to be upscaled to 1600 percent. PhotoZoom and PhotoZoom Pro, from Shortcut (www.trulyphotomagic.com), employ a scaling strategy called S-Spline technology to evaluate the sharpness and evenness of the original image and enlarge it based on this data.

One of the newer products, called SI Pro, is from photographer Fred Miranda (www.fredmiranda.com). SI Pro works from within Adobe Photoshop or Adobe Photoshop Elements and employs something called "stair interpolation" (the "SI" in the product name) to provide high-quality upscaling.

A word to the wise: before investing, make sure that the software you are interested in works with your digital imaging program and operating system!

Don't Just Guess

If you're not sure what resolution you need in your image in order to create the product you have in mind, find out *before* you create your file. There's no point in wasting your time to make complicated refinements on an image that turns out to be unusable. (This is also an important consideration when scanning images—so don't forget to check your scanner settings carefully before each use!)

If you'll be using your image in multiple applications (say you want to make a print but also plan to e-mail the photo to someone), create your image at the largest size you'll need. Make any needed corrections to this large file, then reduce its size and save multiple copies of the image for other uses.

If you take the time to determine the needed resolution and create your image accordingly, you'll be ahead of the game when it's time to output your files!

IT'S *HOW* BIG?

There are two things to keep in mind when creating a digital image. First, ask yourself what the final dimensions of the image need to be. Do you want to make a billboard or a postage stamp? Next, determine what the final resolution of the image needs to be—72dpi? 300dpi? 1000dpi? Once you know the answers to these questions, you'll be ready to create an image (or determine if an existing image will suit your needs). All you need to do is multiply the resolution by the dimensions of the image. Here's how:

Imagine you're making a photo to put in a newsletter. The image needs to be 2" tall and 3" wide on the page, and your printer has told you that the resolution should be 300dpi. To make a file the right size, multiply 2" x 300dpi (for the height) and 3" x 300dpi (for the width). This tells you that you need an image that is 600 pixels tall and 900 pixels wide (600x900).

Later, one of the people in the photo asks if she can have a copy of this file to make an 8"x10" photo-quality print on her inkjet printer. She needs a final resolution of 700dpi. Will the same file work? Nope—your friend will need a much larger image file, one that is 5600 pixels wide (8" x 700dpi) and 7000 pixels tall (10" x 700dpi).

DIGITAL COLOR

When we shoot images on film, we tend to take color for granted and leave it up to the folks at the lab. With digital, we have to know a little bit more to really make our images shine.

Each pixel in an image is assigned a color. It's the combination of these differently colored pixels that creates the picture we see when we look at a digital image. Knowing how these colors are created can be quite helpful.

Primary Colors

If you ever took an art class (or even played with watercolors as a kid), you probably know that combining two or more colors creates new colors. For example, combining blue and yellow paint makes green paint. In fact, almost all colors are actually combinations of some other colors. The exceptions (the very few colors you can't create by combining others) are called primary colors. The primary colors are divided into two sets: additive and subtractive.

The subtractive primary colors are red, green, and blue (RGB). When combined at full strength, the subtractive primary colors yield white. When the colors are all absent ("subtracted"), the result is black. This set of colors, the one we will be using most often in this book, is the set used to create color on your monitor, digital camera, television, etc.

The additive primary colors are cyan, magenta, and yellow. This set of primary colors is used in printing, where inks reflect back light that hits the paper on which a color image or color text appears. When combined at full strength ("added"), the additive primary colors produce black. When the colors are all absent ("subtracted"), the resulting color is white.

Color Modes

In digital imaging, the set of primary colors that are used to create all the other colors in your image is collectively referred to as the color mode (or sometimes the color model).

The individual colors within the set are called channels. For example, if your image is in the RGB mode (the mode used by scanners, digital cameras, monitors, and digital-imaging software), then all of the colors in that image are made up of some combination of red (R), green (G), and blue (B).

RGB. If you combine varying amounts of R, G, and B, you can create about 16.7 million other colors. Because of this, RGB is described as having a wide gamut, a term used to describe the total range of colors (or the tonal range) that can be produced. As you'll quickly learn when you begin working with dig-

ital images, however, the RGB gamut, wide as it may be, is still not as wide as the gamut perceived by the human eye. As a result, subtle colors that your eyes can distinguish in a scene may render as a single tone in RGB. While this doesn't normally present a tremendous problem, it's a deficiency in color range that we pretty much just have to learn to live with.

Grayscale. The Grayscale color mode consists of only one channel—black. In this mode, the pixels are assigned values from 0 (white) to 100 (black). Everything in between these two values will be a shade of gray. Because this mode only has

black, white, and gray tones, you can turn a color image into a black & white one by using your image-editing software to change to the Grayscale mode.

CMYK. This color mode consists of four channels: cyan, magenta, yellow, and black. It is the color mode used for process-color printing—the type of printing that is used to create magazines, books, posters, and other items.

If you need to prepare an image to be printed in a magazine or book, you'll usually make any needed changes to the image in the RGB mode, then convert it to CMYK before sending it to the printer. For tips on making your images look good in print, see my book *Color Correction and Enhancement with Adobe® Photoshop®* (Amherst Media, 2004).

To instantly convert a color image to a black & white one you can simply change the image to the Grayscale mode.

IMAGE FILE FORMATS

They may not seem like much, but those little letters after the dot in the file name actually tell you a lot about an image. Better yet, they tell other programs how to work with the data in your file.

Think of the file format as the language in which the digital image is written. It tells applications, like word processing software or web browsers, that your file is a picture (rather than a text file, for example) and how it should handle all the data in the file to display it correctly on the screen. The file format is indicated by a tag (.TIF .JPG, etc.) added after the file name.

Compatibility

If you travel to France and try to speak Portuguese to the natives, you'll likely encounter some comprehension problems. The same thing can happen when you ask a program to understand a digital file that doesn't speak its language. Some programs are multilingual; they "speak" a wide variety of file formats. Other programs recognize only one or two file formats. If you plan to use your digital image in several programs, read the software's manual to determine what formats it accepts, then save your image accordingly.

Compression

Some file formats give you the option of reducing the amount of memory your computer will need to store an image.

Photoshop
BMP
CompuServe GIF
Photoshop EPS
JPEG
PCX
Photoshop PDF
Photoshop 2.0
PICT File
PICT Resource
Pixar
PNG
Raw
Scitex CT
Targa
✓ TIFF

Adobe Photoshop Elements is able to read and write a wide variety of file formats.

This is called compression. By reducing the memory required to store an image (i.e., the file size), compression allows more images to be stored in a smaller space and permits them to be transmitted over the Internet more quickly.

If this sounds too good to be true, don't worry—it is (at least to some degree). Imagine you crush a soda can. It will take up less space, but it will never look like it did to begin with. With digital compression, the same principle applies—of course, it's rather more sophisticated, and your images won't look as bad as your soda can.

When an image is enlarged, you can really start to see the difference in quality between JPEG compression (left) and LZW (right).

When an image is compressed, equations are applied to arrange the data more efficiently or to remove data that is deemed to be extraneous. As a result, your image won't look as good. However, the loss in quality may not be objectionable—or it may be worth it to have an image that loads quickly.

Two file formats that offer compression are JPEG and TIFF. JPEG offers "lossy" compression, meaning that it removes data and degrades the image. You can, however, control the degree of compression, so you can compress the file just a little (for better image quality) or a whole lot (when quality isn't as important).

The characteristic grid pattern created by JPEG compression (see above)

becomes especially apparent when an image is saved and resaved, compressing it each time. For works in progress, this is not a good file format, but it's standard on the Internet because of the small file sizes it produces.

TIFF offers "lossless" compression called LZW, which doesn't throw anything out (so the image quality remains better), but it also can't compress the image as much. The new JPEG 2000 format also allows you to use "lossless" compression.

You can also select ZIP compression from the TIFF Options window. This is similar to LZW, but it adds a layer of protection that helps reduce the likelihood of corruption when files are sent across the Internet. It's a common compression format for Windows users, but Mac users can also open these files if they have StuffIt installed.

In the TIFF Options window (right) from Adobe Photoshop Elements, you can select no compression, LZW, ZIP, or JPEG compression. In the JPEG Options window (far right), you use the slider at the top of the box to strike the desired balance between file size and image quality. As the file size decreases, so does the image quality.

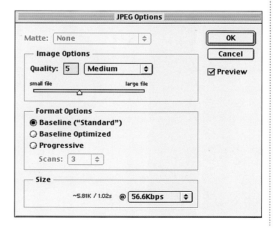

Digital Cameras

Buying a digital camera can be pretty intimidating—there are so many technical factors to consider! When you break it down into a few important qualities, though, it becomes a whole lot easier.

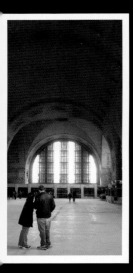

TYPES OF CAMERAS

Walk into any electronics store and you'll be confronted with dozens of digital cameras—in every imaginable shape and size. What's right for you?

There are several types of digital cameras. You can use any type—and you don't need to use the latest model—but some types and models of cameras do offer features that make them more flexible than others. Additionally, it's important to make sure that the camera you choose is comfortable for you to work with—if you have large hands and a tiny camera with tiny buttons, you may find it quite frustrating.

Minicams

Minicams, little digital cameras that shoot small, low-resolution images, are now found in everything from cellular phones to PDAs. In the same class as these are webcams, which can take quick

Webcams fall into the mini-cam class.

shots and video clips for online use. Some very low-end digital cameras (which take screen-resolution [640x480 pixel] images) also fall into this category. These are lots of fun (and great for images you'll only use online), but their low resolution limits your options when it comes to making prints.

Point-and-Shoots

The most common type of digital camera is the point-and-shoot. This type of camera has a built-in lens, fully automatic exposure and focusing, and an image sensor (the "film" of the digital camera) in the 2–6 megapixel range.

It is helpful to use a model with a zoom lens, since this will give you the most choices when composing your images. Also helpful is a full range of exposure settings (like a landscape mode, aperture/shutter priority, etc.—we'll be discussing these in more detail on pages 44–45). Being able to select your aperture and shutter speed manually are also helpful, as is the option to focus manually (although this can be so tricky to adjust on point-and-shoots that you may find it too frustrating to use).

Look for a model that allows you several choices of white-balance settings

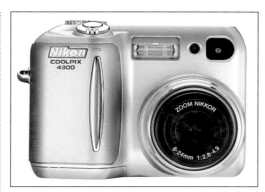

A point-and-shoot digital camera can produce excellent images.

(including the option to create a custom setting, which will be discussed in greater detail on page 25). Finally, it is very helpful if the camera allows you to use photographic filters over the lens.

All of the major camera manufacturers—Kodak, Sony, Fuji, Nikon, Canon, etc.—make excellent cameras, so shop by feature rather than by brand name if you decide to purchase a new camera.

Digital SLRs

Digital SLR (single-lens-reflex) cameras are the most common type used by professional photographers. Because manufacturers have seen a rise in the general consumer interest in this type of camera (and because prices on digital cameras in general have continued to drop), some of these models are now priced under $1000—making them a real option for more photographers.

There are two types of digital SLRs: those with interchangeable lenses and those without. The ability to change lenses is a great asset, giving you the ultimate flexibility when creating your images—but these models are also higher in cost. When buying such a model, note that the lowest price-point for any particular model usually includes the camera body only (no lens). If you own a film SLR, however, you may be able to purchase a digital SLR that will allow you to use your existing lenses—which can save you a lot of money. If you are buying your first SLR (or one that won't work with your existing lenses), most manufacturers offer a package that includes the camera body and one lens at a very reasonable price. You can then continue to add additional lenses to your camera kit as your finances allow.

Digital SLRs usually have an image sensor in the 6 to 10 megapixel range (this number is increasing rapidly). They also offer more advanced metering and focusing features than point-and-shoot models and more flexible flash settings (which can be an important concern if you use your camera to take family pictures, portraits, etc.). Digital SLRs also offer manual focusing, aperture, and shutter control—letting you take control of your images much more easily than with a point-and-shoot model.

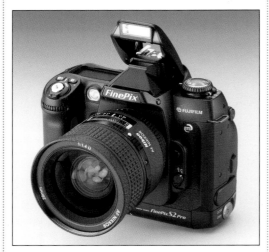

If your budget allows it, a DSLR is a great choice.

MEGAPIXELS

When digital cameras were first produced and sold to consumers, the images they captured were just big enough to fill a small computer monitor (640x480 pixels). Today the story is much different.

With film cameras, the resolution of an image is determined by the size of the photoreactive silver particles on the film's emulsion and the overall dimensions of the film frame itself. With digital, the part of the camera that captures the image is called the image sensor. As with film, its unique qualities determine the resolution of the images captured on it.

Resolution has been an important issue with digital cameras from the beginning. The more pixels you have in your image, the larger the prints you can make, the more fine detail you'll be able to capture, the more you can crop and still be left with a usable number of pixels, etc. More pixels, however, almost always means a higher ticket price—sometimes significantly higher.

What's a Megapixel?

When you look at an ad for digital cameras or peruse a display of them at your local electronics superstore, the one specification you can be sure you'll see listed for every model is the size of the images its sensor can capture. This will be listed in one of two ways.

First, it may be listed as the pixel dimensions—like "1280x960 pixels,"

PRINT SIZE VS. MEGAPIXELS

The following are approximate minimum megapixel requirements for creating a variety of print sizes. These calculations assume that the print is being made at 200dpi. Some print processes may require lower or higher resolutions.

PRINT SIZE	MINIMUM MEGAPIXELS
4"x6"	.6 megapixel
5"x7"	1.3 megapixel
8"x10"	3.2 megapixel
11"x14"	6.1 megapixel
16"x20"	11 megapixel

meaning that the image sensor captures an image that is 1280 pixels long and 960 pixels tall (think of it like measuring the dimensions of a room). Second, the size of the image sensor may be listed in terms of megapixels. The number of megapixels a camera's sensor can produce is determined by multiplying the height of the sensor (in pixels) by the width and dividing by one million. For example:

$$1280 \times 960 = 1,228,800$$

$$1,228,800 \div 1,000,000 = 1.2288$$

This tells us that a camera with a sensor that records 1280x960 pixels could also be said to record 1.2288 megapixels (this will normally be rounded up, so the camera will be listed as a 1.3 megapixel model).

How Many Do I Need?

Most consumer digital cameras now feature a sensor of sufficient size (usually in the 3-megapixel neighborhood) to create nice 8"x10" prints—the largest size most people regularly make. Even low-end models usually have at least a 1.3-megapixel sensor, fine for making 5"x7" prints. Bottom-of-the-line cameras may capture only a .3-megapixel image (640x480 pixels).

So what should you get? Well, first you'll need to decide on the largest size print you are likely to want to make. Don't skimp—if you think there's even a small chance you might want to make an 8"x10" print somewhere down the road, don't settle for a 1.3-megapixel camera. If, on the other hand, all you want to do with your camera is post pictures of your items for sale on eBay, there's not much point in shelling out the cash for a 6.1-megapixel model.

You might decide you like digital so much that you buy a larger model, say a 3-megapixel point-and-shoot, for family pictures and special events, as well as a cheap little .6 megapixel model to keep in your backpack or pop in your pocket for spur-of-the-moment snapshots. That way you'll be all set when you run into Elvis ordering a latte for Marilyn Monroe at the corner coffee shop.

When significant cropping is needed, it helps to have a larger original file. Here, having a 4-megapixel original (left) gives us the flexibility to crop out most of the original image and still have enough data left to make a 5"x7" print. Starting with only a 2-megapixel file (right), making the same crop would leave only enough data for a 3"x4" print.

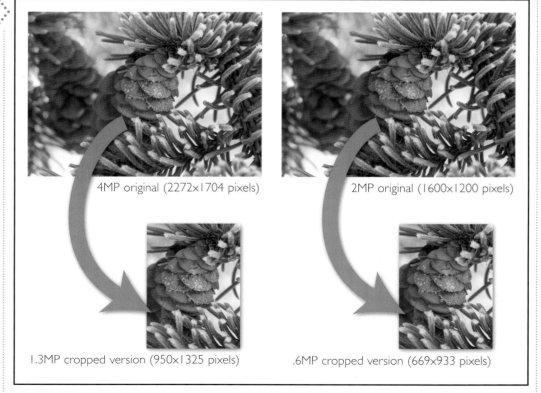

4MP original (2272x1704 pixels)

2MP original (1600x1200 pixels)

1.3MP cropped version (950x1325 pixels)

.6MP cropped version (669x933 pixels)

IMAGE-SENSOR CHIPS

Whether it's a flashy, top-of-the-line digital SLR, a bargain-basement minicam, or an all-purpose point-and-shoot model, digital cameras are all built around some kind of image-sensor chip.

Image-sensor chips are the digital equivalent of film. Instead of light-sensitive materials that must be processed in chemicals in order to make the images appear, image-sensor chips use millions of tiny individual photo sensors to record the light that makes up an image.

When light strikes one of these sensors, information about the quantity and color of the light is recorded. The reading for each sensor is then processed electronically in order to turn this raw data into part of an image. When the data from all of the millions of individual sensors is combined, the result is a complete digital image.

As we saw on pages 20–21, image sensors (like film) come in many sizes. How large the image sensor is (how many light-sensing diodes it has) will determine how much data it can record. With most sensors, each individual diode is equivalent to one pixel in the image.

Types of Sensors

There are two types of image-sensor chips: CCD (charge-coupled device)

DIGITAL NOISE

Noise is the digital equivalent of film grain—tiny irregularities that manifest as specks and spots. Noise is usually thought of as a bad thing because it represents an "error" in the recording of an image. However, noise can also be a good thing—it can prevent digital images from looking too artificially smooth, it can sometimes be added to an image to disguise other problems (like distortions caused by JPEG compression), and it can even be created intentionally to add a mysterious or gritty look to an image. In digital, as with film, higher ISOs (the measurement of the degree of light sensitivity in a image-sensor chip or film) mean more noise; lower settings produce images with less noise. Noise can also be the result of disturbances in the currents generated by CCD or CMOS image sensors—disturbances that can be caused, for example, by electronic interference, heat, mechanical instability, etc.

and CMOS (complementary metal oxide semiconductor). Both are made of silicon and both have millions of tiny light sensors. The main difference between the two types of chips has to do with how they handle data once it is collected by the individual sensors. With a CCD chip, this data is moved from the chip to other on-board electronics to be converted into usable digital values. With a CMOS chip, the conversion takes place within the individual light-sensitive element of the chip.

Does it Matter?

So what does all this electronic mumbo jumbo mean for digital camera users?

Well, for a long time, CCD chips were the image sensors of choice for digital cameras—and they are still by far the most common chip used in consumer models. CCDs provide excellent image quality and produce relatively little noise (see facing page). However, because these chips require a separate processor to handle the data recorded by the individual sensors, they require special manufacturing processes that make them rather pricey to produce. Cameras designed around CCD image sensors actually require several chips (as many as eight) to record and process image data.

Because the data processing in a CMOS chip occurs right on the image sensor itself, it's possible to design cameras that can actually function with only one chip. As you can image, that means much lower production costs. It also helps to reduce the required size of the camera and to minimize battery consumption—both good things for most digital camera users. The drawbacks? Because some of the area on the image-sensor chip is taken up by the electronics needed to process the signals from the sensors, some of the light hitting the chip actually strikes the areas around the sensors rather than the sensors themselves. As a result, CMOS chips are about half as light-sensitive as CCDs.

Recently, however, CMOS technology has advanced to the point where this type of image-sensor chip is a real alternative. This is especially true because of certain advantages (too complex to detail here) the CMOS format has when dealing with really high resolutions. As a result, CMOS image-sensor chips are now being used in many large-format professional cameras, digital SLRS, and even some consumer cameras. Canon, in particular, has aggressively begun using CMOS chips in their new digital SLRs—including the Digital Rebel, one of the most affordable digital SLRs on the market.

CAMERA FEATURES

With digital, cameras have changed a lot. There are many more features and options to keep your eyes on when buying (and to consider using when shooting)!

Digital cameras are, on the whole, a lot more sophisticated than film cameras. When buying a digital camera (or learning to use a model you already have), here are some things to look for.

Image Modes

Most cameras offer several preset shooting options—generally designed to produce good results with a particular kind of subject. These often include a sports mode (for action shots), a landscape mode (for, you guessed it, landscape images), a portrait mode (for people pictures), etc. The uses for and advantages of each of these modes will be covered in detail on pages 44–45.

White Balance Settings

Color accuracy is important; we want our reds to look red, our greens to look green, and our skin tones to look natural and healthy. With a film camera, ensuring color accuracy means picking a film that is matched to the light you'll be shooting in—daylight-balanced film for shooting under natural light or with flash, or tungsten-balanced film for shooting under incandescent lights (like household lamps). If you don't use the right film, the colors will look wrong.

For example, if you shoot daylight-balanced film when your subject is actually illuminated by a lamp, the photo will have an overall yellow color cast.

With digital, the camera can compensate and balance the colors for accuracy under just about any kind of light—sunlight, fluorescent light, tungsten light, etc. Many cameras also offer even more refined settings for overcast light (which isn't as warm and golden as light from the sun under other conditions), flash, and other light sources.

The image on the left was shot with the white balance set to auto. The image on the right was shot with the white balance set to daylight. As you can see, the color rendition is quite different—although both are certainly acceptable.

In addition, most cameras now offer automatic white balance settings and custom white balance settings. With the auto setting, the camera evaluates each shot and tries to create an ideal color balance for the scene. This is a great feature for snapshots—especially when you are moving quickly from one subject to another and don't want to mess around with resetting the white balance for each type of lighting you encounter.

The custom white balance setting is great when you want to take a bunch of pictures under the same lighting conditions and make sure they all match. Imagine you wanted to take a series of portraits of the people at a family reunion. You could set up a custom white balance setting for the area where you wanted to take the pictures (say, the backyard) and then photograph each subject. When it came time to frame a group of photos, you'd be sure that the colors would all match (the grass would not be a little more yellow in one image and a little more blue in another, etc.).

Auto *vs.* Manual

Speaking of auto and manual settings, depending on the camera, you may also find the option to make your exposures manually, rather than automatically. If you are familiar with f-stops and shutter speeds, you may want to try this—especially in situations where the auto settings are not providing the best possible results.

Panoramics

Digital imaging has really revived the popularity of panoramic images—long, narrow photographs that often show as much as a 360-degree view of a scene. Many cameras now offer a mode that helps you shoot a sequence of images that you can later use software to combine into a single panoramic shot. For more on this, see page 62.

Digital Video Clips

While your digital camera won't (yet) really do double duty as a digital video camera, most point-and-shoot cameras let you produce short, low-resolution movies. They can also, however, eat up lots of space on your memory card (meaning you'll have less room for photos!), so be sure to buy a large media card if you think you'll want to shoot these regularly.

BATTERIES

Digital cameras can really chew through batteries! Battery life will depend on a lot of variables—the camera model, the battery type, how often you shoot with flash, how long you leave the LCD screen on, etc. Keep in mind that most cameras employ proprietary battery packs, so getting back to shooting when your battery dies isn't just a matter of grabbing a new one at the corner drugstore—it could take a few hours to recharge a dead battery. Therefore, if it's in your budget, having a backup battery on hand isn't a bad idea. On the road, consider purchasing an adapter that lets you charge your battery from the car's cigarette lighter—much better than having to wait until you get home or back to your hotel to recharge!

MEMORY CARDS

CompactFlash! Secure Digital! xD! Microdrives! Memory Sticks! The list of memory card formats goes on and on—and it keeps growing every day as new and improved models are introduced.

Memory cards come in all shapes, colors, and sizes—and they've become so ubiquitous you can now pick them up at drugstores, photo labs, and just about anywhere else you used to purchase film.

What They Are

Memory cards are an important part of any digital camera setup. Although they are sometimes referred to as the digital equivalent of film, unlike film, memory cards don't actually have anything to do with capturing an image—that's the job of the image sensor (see pages 22–23). Once the image sensor has captured the photograph, it transfers the data to the memory card where it is stored. Unlike film, memory cards can also be used again and again (which is a good thing, since they certainly aren't cheap!).

Types

There are two basic types of cards: flash memory and microdrives.

Flash memory cards are solid state, meaning there are no moving parts; electronics rather than mechanics do the work in these cards. There are many card formats within this group. The CompactFlash (or CF) type is probably

Memory cards come in a wide variety of formats and capacities from a large number of different manufacturers. Before buying a digital camera, you might want to research the cost of the memory cards it requires—some formats are a bit more than others!

Microdrives are more delicate than flash memory cards, but they offer much higher storage capacities at more reasonable prices.

the most common, but Memory Stick, Secure Digital (or SD), xD, and Smart-Media are also popular. These cards have several advantages: they are lightweight, noiseless, reliable, and save images quickly. The main disadvantage is their cost.

Microdrives, on the other hand, are miniature hard drives (just like in your computer). Because microdrives feature internal moving parts, they are more delicate than flash cards. While flash memory cards can survive some serious abuse (they are often reported to survive trips through the laundry), even *dropping* a microdrive can cause problems.

Why doesn't everybody just use flash memory? The answer is that microdrives are much cheaper and the capacity of each card is much higher. This is especially important with cameras, like digital SLRs, that create very large files—

meaning you need lots of storage space if you want to shoot numerous images without having to change cards.

If you're a multi-camera family, consider looking for models that all use the same type of memory card. That way you can share cards and card readers (see page 56). Just be sure to reformat the card before switching between cameras.

Capacity

Memory cards are labeled (and priced) according to their storage capacity. The smallest ones hold only 8MB of data, while the largest now hold over 4G. The size of your camera's image sensor, the file format you choose to shoot, and the amount of compression you set your camera to use (sometimes called the image-quality setting) will determine how many images a particular memory card will hold.

With digital, people tend to shoot a lot more images than they did on film, so don't skimp—with a large card, you can shoot for hours and never have to swap it out (so you'll never miss a shot). For most people, a 256MB card is really the smallest comfortable option for a day of shooting (say, on a vacation)—and a 512MB card is very nice. Still, it's always a good idea to have a backup card with you, just in case.

DELETING IMAGES VS. FORMATTING THE CARD

After you've transferred all the images off a card and backed them up (at least once) to CD-R or DVD-R, return the card to your camera and select the "format" option from your in-camera menu (consult your camera's manual for more information on this) to remove all the images. Formatting the card, rather than just deleting all the images, completely resets the card and helps prevent potential problems and disk errors.

LCDs AND VIEWFINDERS

Most digital cameras give you two ways to set up your images—on an LCD screen or on a viewfinder. Which way you choose will depend on the circumstance and your particular preferences.

Probably the most noticeable difference between film and digital cameras is the LCD screen on the back of the digitals. This has really changed the way we take pictures. For one thing, you don't need to hold the camera up to your eye anymore; you can hold it at arm's length, over your head, etc.

LCD Screen

The LCD screen on the back of a digital camera is, by and large, the means of interacting with the camera. There are a few buttons and dials, but a lot of your settings will be made using the on-screen menus. Of course, most people also compose their images using this screen and use it to review the images they have already shot. That makes the LCD screen a very important feature. So what should you look for?

First, think about the size of the screen. Larger screens mean bigger image previews—and for most people, that means an easier experience composing and reviewing images. After all, it's pretty tough to get a good idea of what your image actually looks like when it's the size of a postage stamp! With cameras getting smaller and smaller, though, many LCD screens are also shrinking.

That may be okay for a camera you just want to have in your bag for everyday snapshots of friends and family, but it may not be the best option for a camera you want to use to take breathtaking landscape images on your once-in-a-lifetime trip to China. Larger screens are also good for people whose eyes are maybe not what they used to be—so if you have any vision concerns, go for a model with a larger screen.

Also important is the legibility of the menus on the screen. Check that the type is large enough and bright enough to read easily. You have enough things to worry about when crafting your images without having to struggle to read the menu options.

The position of the LCD is also important. This is where it pays to buy a camera in a store (rather than online) where you can actually lay your hands

STRETCH THE JUICE

Powering the LCD screen is a big battery drain. Therefore, most cameras let you turn off the LCD screen when it's not in use—*without* turning off the camera. Digitals usually take a few seconds to boot up when you turn them on, so this conserves power while leaving you ready to shoot on a moment's notice.

on the model you are considering. Spend some time holding the camera and see where your hands tend to fall. If your natural hand position puts your thumb in the middle of the LCD, you're going to be spending a lot of time cleaning thumbprints off the screen—and you probably aren't going to enjoy your camera as much as you could.

Finally, look at the brightness of the LCD. If you have to struggle to see the image because the LCD screen is too

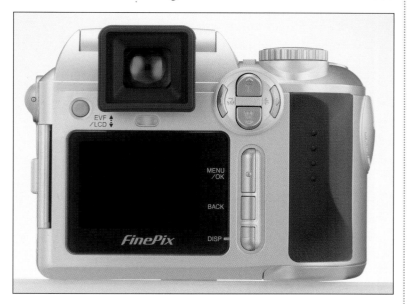

The position and size of the LCD screen varies from model to model.

dim, look for another model. When trying out a camera in a store, look for some bright lights and check out what the screen looks like with a lot of light falling on it—glare can be a big problem with these.

Viewfinder

Most digital cameras also come with a traditional type of viewfinder (the kind where you lift the camera to your eye and look into a little window). On digital SLRs, in fact, this is the only way to compose and shoot your images; the LCD screen on these models is used only for image review.

So why would you want to use this viewfinder instead of the fancy LCD screen? Well, one reason is, as noted above, when light falls directly on the LCD screen, glare can make it hard to see your image clearly. In that case, the viewfinder is a better option.

Some people also just prefer to shoot the way they are used to shooting on their film cameras.

Other people find that they get a little too wrapped up in the image previews coming up on the LCD screen and stop looking at their subject. Using the viewfinder lets you concentrate and look at the images later—which can be good for fast-paced shooting.

Finally, when using the viewfinder you can turn off the LCD screen completely—and that dramatically reduces the power requirements of the camera (meaning your batteries will last longer). This is a good strategy, then, for when your batteries are running low but you really want to keep shooting.

LENSES

When you take a picture, you are recording light that enters the camera through a lens. That makes the function and quality of your camera's lens (or lenses) critical for achieving top-quality images.

Megapixels, digital movies, LCD screens—it's easy to get caught up in these more glamorous features when looking at a digital camera. But, when it comes right down to it, every single picture you take will be through whatever lens is on your camera, and that makes those curved pieces of glass pretty important.

Types of Lenses

The type of lens on a digital camera tends to depend on the type of camera. In most cases (except for high-end cameras), digital cameras feature built-in lenses that can't be changed. This makes it important to determine the lens you want before buying a new camera.

Fixed. Minicams and low-end point-and-shoot models often offer fixed lenses. This means that, when you look through the camera, there will be one view of the scene—and that's it.

Zoom. Some minicams and most point-and-shoot models feature a zoom lens. This type of lens lets you choose between several views of a scene. You can zoom in (use a telephoto setting) to get a closer view, or zoom out (use a wide-angle setting) to see a more broad view. This gives you a lot more options when it comes to composing your photographs (see pages 38–39). Although a zoom lens adds to the cost of the camera, most people consider it a must.

The power of a zoom lens (how tightly it can zoom in, how widely it can zoom out) is expressed in terms of its focal length. This is a way of describing how the lens will render a scene or subject on the recording medium (be it film or a digital image-sensor chip).

While the magnifying power of a given lens is constant, the lens may *function* differently depending on the size of the film frame or image-sensor chip that is in the camera. As noted on pages 20–21, however, the sizes of the image-sensor chips in digital cameras vary widely. If the power of the lens was calculated based on each model's unique chip size, this would make it just about impossible to really compare lenses from camera to camera. Therefore, manufacturers base their calculations of focal lengths on the size of a classic 35mm film frame. If you come to digital from shooting 35mm film, this also makes it handy to choose a lens (or lenses) that match up with the lens(es) you used on your film camera, ensuring you'll get the focal lengths you want.

The lens on a digital camera may be listed in terms of focal length, measured in millimeters (e.g., 18–70mm). This may also be listed as its "effective focal length" (i.e., how it would work on a 35mm camera). It may also be listed as something like "4x," meaning that the most telephoto ("zoomed in") setting is four times greater than the most wide-angle setting ("zoomed out") setting. For example, an 18–70mm zoom lens could also be listed as a 3.8x zoom ($70 \div 18 = 3.8$).

Another specification you'll often see listed with lens data is optical (or actual) zoom *vs.* digital (or enhanced) zoom. The number you want to look at is the *optical* value. This is the amount of enlargement actually produced by the lens itself. "Digital zoom" is not really zoom at all—it's a software function that simply crops the image in the camera. This results in poor image quality. If you want to move in more tightly on a subject than you can with your lens, you're better off either moving your camera closer to the subject or, if that's not possible, cropping the image later on your computer where you have more control (see pages 84–85).

Interchangeable. Most high-end cameras, like digital SLRs, employ lenses that can be removed and switched. You can select fixed focal-length lenses or zoom lenses, telephotos or wide-angles—whatever you want. The only drawback is that these systems can be very expensive. If you want the ultimate flexibility, however, it's definitely the best way to go!

SOME OTHER LENS-RELATED CONCERNS . . .

Close Focusing

If you like to take close-up photos, you'll want to make sure your camera allows for close focusing. Without a close-up setting (usually indicated by a flower icon on the camera body), you may only be able to get to within a few feet of a subject before your autofocus stops working. With the close-focus setting active, you may be able to bring your lens to within a few inches of your subject and still get a crisp, well-focused shot.

Filter Adapters

Filters attach to the lens of the camera (or, on some models, over the lens, using an accessory filter adapter) and allow you to adjust the light entering the camera in creative ways. You can add starbursts, remove glare, enhance color—and that's just the start! If you want the maximum in flexibility, therefore, look for a digital camera model that allows you to use filters—not all models do.

Accessory Lenses

If your camera accepts filters, you may also be able to purchase a wide-angle or telephoto accessory lens to stretch the function of your built-in lens. The availability of these lenses isn't an excuse to skimp on zoom range when buying a camera (the image quality when using them usually isn't quite first-rate), but they can be very useful in a pinch!

FLASH

Photography is, literally, the art of recording light. Sometimes, however, there's not enough light to be found. Enter the flash— a light source that, used correctly, can turn night into day!

Built-in flash has been on cameras for a long, long time, but most cameras gave you very little control over it. With digital, the controls are (at least on most models) significantly enhanced—and the LCD screen lets you make sure you've achieved the results you want before moving on to your next shot.

Automatic *vs.* Manual

When you shoot in the fully automatic mode, your camera will choose the amount of flash needed and the settings required to produce a well-exposed image. You may, however, be able to turn the flash off in situations where you think it's not really needed.

If a scene seems well lit but your camera insists on using the flash, it probably means that the shutter speed the camera is selecting is on the long side. Most people can't hold a camera totally motionless for more than a small fraction of a second, and the result is blurry images. If, however, you can find a place to stabilize your camera (on a tripod, a shelf, etc.), you can probably get away with turning off the flash if it's not pro-

Images taken with on-camera flash as the main source of light in the photograph tend to have sharp shadows outlining one side of the subject (left). If there's enough light to use a longer exposure instead of the flash, you can usually create a more attractive shot (right). This may require a long shutter speed, so shooting from a tripod is a good idea.

In the image on the left, the subject stands in front of the faintly illuminated columns of an art museum. The columns, however, are too distant for flash to do any good.

The answer is the night portrait mode. In this mode, the subject is lit by the flash—but then the camera continues to expose the image, allowing the less intense light in the background to contribute more significantly to the final exposure. A tripod is strongly recommended when shooting in this mode (although you can get some interesting blur effects by quickly moving the camera immediately after the flash fires).

ducing the effect you wanted to see in your image.

If your camera offers manual settings, consult your user's guide for flash operations. On most cameras, you'll be able to reduce the flash output to better balance it with the other light in the scene and avoid some of the pitfalls (see facing page, bottom) of flash lighting.

Red-Eye Reduction

Red-eye occurs when the lens and light source (usually an on-camera flash) are directly in line with the subject's eyes. To combat this simple fact of anatomy, most cameras now include a red-eye reduction setting. When this setting is used, a beam or flash of light immediately precedes the flash of light with which the exposure is made. The initial burst of light closes down the pupil, preventing the second burst of light from reflecting off the retina and back into the camera (which is what makes the center of the eye look red). If red-eye still occurs, you can fix it easily in your image-editing software (see pages 82–83).

Night Portraits

The night portrait mode allows you to balance a dark background with a flash-lit foreground subject. See the images and caption above to learn how this works.

FLASH DISTANCE

Bright as it may seem, light from an on-camera flash only travels a few feet (usually in the range of 10 to 15) before it's too weak to make a good exposure. Therefore, if your subject is too far away (like at the other end of a football field), flash won't help. Conversely, flash is very intense close to the camera—so intense it can wash out too-close subjects. If your flash-lit subject's skin tones look pasty, take a few steps back and you'll usually get better results.

SHUTTER CONTROLS

Digital point-and-shoot cameras offer you more shutter controls than most comparable film cameras—and that makes it even easier to create great images in some tricky situations.

As with a film camera, the shutter is what opens and allows light into the digital camera to make an exposure. *When* it opens and *how long* it is open (the shutter speed) are important concerns for getting a correct exposure. They also have implications for those who really want to control their images.

Shutter Lag

One of the big problems with early digital cameras was that there was often a significant delay between when you pushed the shutter button and when the photo was actually taken. That made it really hard to take action shots! Today's cameras are a lot better, but there's usually still a tiny delay. Therefore, when timing your image is important, you'll want to try to anticipate the action and pop the shutter just before it peaks. Experience with your camera will make this a bit easier.

Action Sequences

Most digital cameras offer a burst or continuous shooting mode (sometimes also called a sports or action mode). When you use this mode, your camera will keep taking images for as long as you hold down the shutter button (until

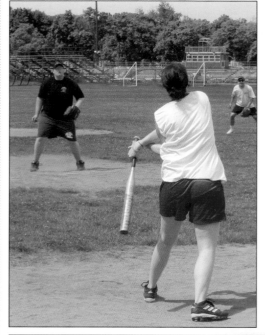

If you click the shutter at the peak of the action, shutter lag can cause you to miss the moment (left). Instead, you need to anticipate the action and click the shutter just before it's about to happen (below). Depending on what you're trying to capture, this can be pretty tricky!

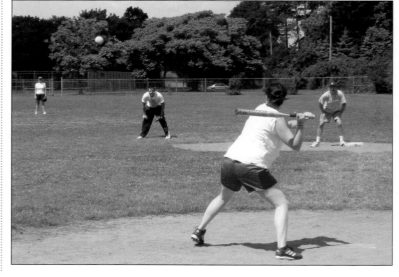

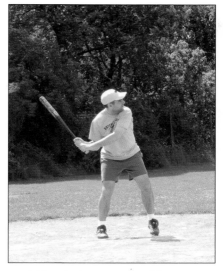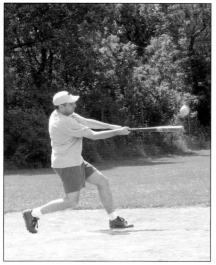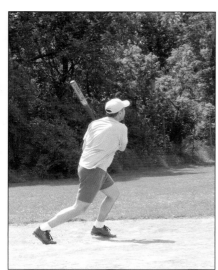

Using the burst or continuous-shooting mode creates a sequence of images, giving you better odds of capturing exactly the shot you want. Photos by Paul Grant.

either your memory card runs out of storage space or your camera runs out of processing memory and has to pause before shooting the next image).

This is great for fast action—but read your camera's manual closely. On some models, choosing this setting will automatically switch the camera to a lower resolution setting or a higher compression setting. This makes the files smaller so that more images can be processed but may leave you with too

few pixels to make the size print you want of your best image.

Shutter Speed

Here's (literally) the long and short of shutter speeds: when you choose a long shutter speed, subjects in motion will be blurred in your image; when you choose a short shutter speed, subjects in motion will be frozen in your image.

If you look at the softball shots on these two pages, you'll see that the batters are all pretty much frozen in time. That's because a short shutter speed was used. Now, look at the waterfall image to the left. Here, a long shutter speed was used to blur the motion.

Remote Shooting

Like most point-and-shoot film cameras, your digital will probably have a timer that allows you to set the camera and then duck into the shot. Depending on the model, your camera may also come with a remote control. This nifty device lets you stay in front of the camera and shoot as many images as you want.

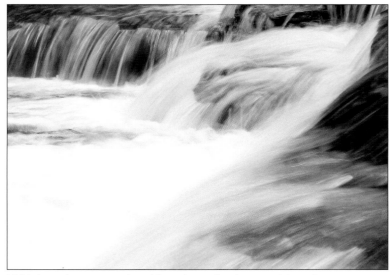

With long shutter speeds, subjects in motion become blurred.

ADVICE FOR BUYING

Digital cameras are a lot less expensive than they were a few years ago—but they're still far from cheap. Unless you have unlimited resources, you'll want to consider your purchase very carefully.

No camera is the right one for every photographer—our needs and tastes are all too different. What's important is to figure out what you want, then find a model that fits those needs. The following are a few things to consider:

1. **Megapixels**—How big do you want to be able to make prints?

2. **Lens**—Do you need a lot of zoom or just a little? Or would a camera with interchangeable lenses fit your needs better?

3. **Special Features**—Do you like to take pictures at your daughter's soccer games? If so, make sure there's a continuous shooting mode. Do you love taking landscape photos? If so, you'll probably want a panoramic mode as well as a landscape setting. Maybe close-ups of flowers suit your fancy—which means you'll want to be sure there's a macro or close-up mode.

4. **Memory Card**—If this is your second digital camera (or someone else in your household has one) consider sticking with a model that uses the same memory card format so you don't have to buy new media.

5. **Cost**—Know your budget. Don't break yourself to get features you don't even need (equally, don't skimp and pass up on things you want just to save twenty bucks).

You may want to rank the qualities you are looking for as "needs" and "wants." When you're shopping, you'll only want to look at models that have *all* your needs—then you can concentrate on finding ones that have *as many as possible* of your wants.

Finally, take the time to do your homework. Spend an evening online narrowing down the models you are interested in and reading reviews (some resources for this are listed on the facing page). Talk to the folks at your local camera shop and see what their experiences have been and what they recommend (and, if possible, support them by buying locally instead of online).

You probably also have friends who already own digital cameras. Ask them what they love (or hate) about theirs. It can be very revealing—they may have had problems or discovered advantages you'd never think of!

RESOURCES

Before you buy, check out some of these helpful resources. Visit the manufacturer's web site for a complete list of specifications, but also be sure to read some reviews on other sites. For serious critiques, look for reviews that are written by average users—people who are likely to have skills and demands that are more similar to yours than those of a professional photographer or photography-equipment reviewer. The following are some good resources:

Camera Manufacturers

Argus—www.arguscamera.com

Canon—www.canon.com

Casio—www.casio.com

Concord—www.concordcam.com

Contax—www.kyoceraimaging.com

Fuji—www.fujifilm.com

Hewlett-Packard—www.hewlett-packard.com

Jenoptik—www.jeimage.com

JVC—www.jvc.com

Kodak—www.kodak.com

Konica Minolta—www.konicaminolta.com

Kyocera—www.kyoceraimaging.com

Leica—www.leica-camera.com

Mustek—www.mustek.com

Nikon—www.nikon.com

Olympus—www.olympus.com

Panasonic—www.panasonic.com

Pentax—www.pentax.com

Polaroid—www.polaroid.com

Rollei—www.rollei.de

Samsung—www.samsung.com

Sanyo—www.sanyo.com

SeaLife—www.sealife-cameras.com

Sigma—www.sigmaphoto.com

Sipix—www.sipixdigital.com

Sony—www.sony.com

Toshiba—www.toshiba.com

Vivitar—www.vivitar.com

Media Reviews

Amazon—www.amazon.com

c|net—www.cnet.com

Consumer Reports—www.consumerreports.org

dcviews—www.dcviews.com

Digital Camera magazine—www.digicamera.com

Digital Camera Resource Page—www.dcresource.com

Digital Camera Review Spot—
www.digitalcamerareviewspot.com

Digital Photographer magazine—
www.digiphotomag.com

Digital Photography Review—www.dpreview.com

ePhotozine—www.ephotozine.com

Imaging Resource—www.imaging-resource.com

Let's Go Digital—www.letsgodigital.org

Megapixel.net Webzine—www.megapixel.net

pcphoto review—www.pcphotoreview.com

Photo Techniques magazine—www.phototechmag.com

Popular Photography magazine—
www.popularphotography.com

Shutterbug magazine—www.shutterbug.com

Steve's Digicams—www.steves-digicams.com

User Reviews

Amazon—www.amazon.com

Ask an Owner—www.askanowner.com

Camera Forums—www.cameraforums.net

Digital Camera HQ—www.digitalcamera-hq.com

Epinions—www.epinions.com

Digital Shooting

Once you've figured out the buttons and menus on your digital camera, it's time to get out and start shooting. If you're like most people, you'll find it's a lot more fun than with a film camera—but there are still a few unique challenges.

COMPOSITION

If you want your images to look more polished and professional, a good place to start is with composition— a major factor in the success of any image.

Composition is the term used to describe the conscious placement of subjects within the frame. Believe it or not, more than any other quality, composition can make or break a photograph. Let's start with what not to do.

What to Avoid

The most boring composition you can use is one where you simply center your subject in the frame. This "bull's-eye" type of composition is very static and doesn't encourage the viewer's eyes to linger and roam around the frame. Their gaze hits the center of the image, identifies the subject, and is then ready to

move on to the next image! Placing your subject off center instead makes the viewer's eyes travel around the image, evaluating the main subject and the areas around it—which is just the reaction you want! By and large, the only time you might want to center something in the frame is if you are trying to show symmetry—say a single, perfectly symmetrical tree.

You should also look to eliminate potential distractions. For example, our eyes are drawn to areas of contrast in a frame. Imagine you have photographed a scene of rolling green hills. Now imagine that there is one tree on one hill with

COMPOSITION TIPS

1. **Use the LCD Screen.** Composing on the LCD screen usually makes it easier to imagine what your print will look like—and any problems seem a bit more obvious.
2. **Try Some Variations.** Rarely is your first idea about how to compose a scene the best one. Try out some variations—remember, with digital, it doesn't cost you a cent!
3. **Zoom In, Zoom Out.** If your camera has a zoom lens, try starting with a wide angle setting, then begin zooming in to pick out just what's important. Often, compositions fail because they include too much. Try to eliminate anything that doesn't help tell the story you want your viewer to see in your image.
4. **Don't Forget Verticals.** Most photos are taken as horizontals, because that's how we tend to hold our cameras. Many subjects, however, work much better in vertical compositions, so don't be lazy—tip your camera on end for a few shots!

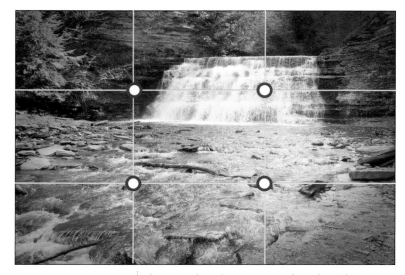

Composing according to the rule of thirds creates more dynamic images. Here, it gives the water room to flow diagonally through the frame—drawing your eye along with it.

leaves that have turned red. Where are your eyes going to be drawn in that photograph? Right—directly to that one red tree. If you've composed the image intentionally to show the contrast of that tree with the surrounding ones, this can be a great thing. If you really wanted to show the shape and texture of the rolling hills and didn't even notice the red tree until you got home, it can be very disappointing.

Another problem that everyone has sooner or later is that we all tend to get wrapped up with what's at the center of our frames and therefore miss seeing distractions at the edges. A common one is a branch sticking into the edge of the image. It's easy to miss when shooting, but you'll notice instantly when you get home and review your images! Make it a habit to check the edges of the frame before you shoot each image.

The Rule of Thirds

The rule of thirds is a centuries-old formula used by photographers, painters, and other artists as a guideline for determining a strong place to position their subject within the frame.

According to the rule of thirds, the image frame is divided into thirds (like a tic-tac-toe board). This is shown in the diagram above. Subjects can be successfully placed along any of these lines, and may be emphasized by placing them at the intersection of any two lines (these intersections are sometimes called "power points").

Whether your image is horizontal or vertical—even a panoramic—this guideline applies in exactly the same way.

When using image-editing software to crop your images, you should also keep the rule of thirds in mind, since cropping can change the composition—for the better or the worse, depending on how you do it.

Note that this is not a hard-and-fast rule. Your subject and aesthetic sensibilities will ultimately determine the best composition for each image, but the rule of thirds provides a good place to start and will help you remember to avoid centering the subject.

EXPOSURE

With film, you weren't sure the exposure was right until you got your prints back from the lab. With digital, you can instantly review each image and make sure it's right—so no more disappointing surprises!

If you're accustomed to shooting negative (print) film, you'll need to adjust your normal exposure techniques somewhat as you make the leap to digital. With negative film, the usual exposure strategy is to meter and expose for the shadows, ensuring that you will get detail in the darkest area of your image. Negative film is great at holding detail in bright highlights, so these areas become a secondary consideration when exposing. Negative film also has a high exposure latitude, meaning that the exposure you (or your camera) select can be significantly off from the "perfect" exposure for the scene and still yield a usable negative.

With digital the story is a little bit different. Shooting digitally, as far as exposure is concerned, is more like shooting slide film. Instead of exposing and metering for the shadows, you expose and meter for the highlights. Also, your exposure must be more precise to produce a usable image—one with printable detail in both the highlight and shadow

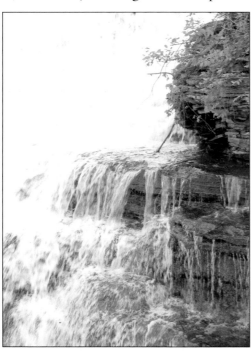
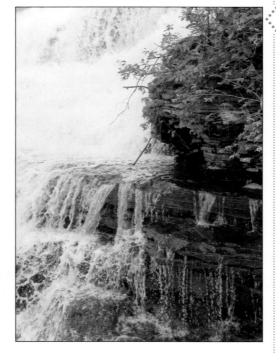

For the image on the left, the exposure was metered off a dark area on the rocks. This rendered the stones well, but the waterfall is so lacking in detail that it's almost impossible to even identify. On the right, the exposure was metered off the water, producing an exposure that better retained detail in this area. The rocks may be a little dark (depending on your tastes), but they could be lightened using your image-editing software.

READING HISTOGRAMS

Most digital cameras allow you to view what's called a "histogram" for each image you shoot. Using this graphic representation of the tones in your image, it's easy to get a good idea of where there might be problems.

Here's the idea: in the histogram, the tones in the image are broken down into data that is represented in a diagram from left (pure black) to right (pure white). Tones in the middle area are called "midtones" (somewhere between black and white). The taller the jagged black data is over a given area of this black-to-white scale, the more tones in the image fall into that range. For example, in the first histogram (top) most of the tones are to the far left. This tells you that most of the image is very dark. In the second example (center), most of the data is over the light areas, telling you that the image is mostly very light. In the final example (bottom), we see a more typical arrangement—some light, some dark, but most tones somewhere in the middle.

The histogram will be different for each image—and there's no "right" histogram. What you should look for in terms of exposure, however, is a histogram that tapers down toward the ends (even if steeply) and doesn't crowd up over the pure white or pure black points (the extreme ends). This can be a sign of loss of detail in either the highlights or the shadows.

areas. This is because digital has an annoying tendency to "blow out" (render as pure, bald white with no detail) the bright highlight areas in a scene. The results can be really unattractive—as you can see in the photo at the bottom left of the facing page.

If this sounds pretty foreboding, don't worry—there are a lot of great things about digital that, ultimately, make it easier to get a well-exposed image than ever before.

The process is really just this simple: meter for a highlight in your scene. If you are using a camera in the manual mode, set your aperture and shutter speed to the reading for the highlight area. With a camera in the auto mode, use the exposure lock to meter and lock in the highlight exposure.

Then, shoot your picture. In the image review mode, examine the highlights carefully. Many cameras let you zoom in on the image to see more detail. Because blown-out highlights are a known issue with digital, many models let you review your images in a mode where areas of pure white with no detail blink in the preview. Other cameras let you look at a histogram of the image (see above).

If you spot a problem with the highlights, reshoot the image at a faster shutter speed or smaller aperture. Many cameras also offer exposure compensation controls; if you are shooting in the auto mode, this is a good way to reduce the exposure of the image to control the highlights.

FOCUSING

No matter how beautifully composed and elegantly lit the scene may be, if it's blurry, it just won't look as good as it could. Poor focus is a quick way to ruin just about any image.

Focus is a big issue for photographers. Shooting digitally, however, puts some very sophisticated tools at our fingertips to ensure we can keep our images sharp.

Autofocus

The autofocus systems on today's cameras are extremely sophisticated and provide great results for most scenes. There are still a few things that can trip them up, though. These include: very low contrast subjects, scenes that mix close and far objects, scenes with extremely bright subjects at the center of the composition, and quickly moving subjects.

Focus Lock

Many of the aforementioned problems can be solved using focus lock. To do this, aim your camera at a second subject that is about the same distance from the camera as the intended subject. Focus on this and press the shutter button halfway down to lock the focus setting. Keeping the button half pressed, recompose the image and shoot.

Manual Focus

For really tricky subjects, you may prefer to use manual focus. On a point-and-

The macro setting on a point-and-shoot camera lets you get up quite close to small subjects and still keep them in focus.

In portraits, the main area to concern yourself with is the eyes. If those are sharp, the focus elsewhere in the portrait almost doesn't matter. If you want a contemporary feel, letting almost everything but the eyes go slightly out of focus creates a very appealing look.

Advanced Features

Many SLRs now offer really advanced focusing features that allow you to quickly shift the focus to an off-center subject or even to automatically track a moving subject and retain focus. If your camera offers these features, learn how they work and put them to use!

As noted on page 31, many cameras also allow for close focusing—making it possible to take sharp images even when your lens is only a few inches from the subject.

Checking the Focus

After you shoot an image, preview it on the LCD screen and (if your camera allows) zoom in on the most important element in the frame to make sure it's sharp. In a portrait, this is usually the subject's eyes. If the eyes are not sharp, reshoot—and be thankful you found out about the problem while there was still a chance to correct it!

Sharpening

If your focus is close but not quite perfect, most digital imaging software can help you to improve it. See pages 92–93 for more on this.

shoot camera (if it's offered), getting good results with the manual focus can be a bit tricky, so consult your manual for tips and evaluate your images carefully to ensure you've focused correctly.

On an SLR, simply switch to manual focus mode and adjust the focusing ring on your lens until the focus indicator on your LCD screen indicates that the image is correctly focused.

MORE ON FOCUS

Of course, totally sharp focus isn't right for every image; for some shots you may want to use blurring to show that the subject is in motion or to make the image look jittery. As the artist, the choice is yours!

IMAGE MODES

The image modes give you some great shortcuts when you want a little more control over your photos. They also provide ways to make getting special types of shots a little easier.

Most digital cameras offer a range of features that were not options on film cameras. If you know how to use these settings, they can help you create better images. The specific settings will vary somewhat from camera to camera, but the following are some of the most common options. Check your camera's manual for details on your model.

On most models, the image modes are selected from a dial on the top of the camera. On others, these options are selected from on-screen menus.

Auto

Usually indicated by "auto" on the image mode dial or menu, in this mode the camera makes all the decisions for you. With today's sophisticated metering systems, this often provides a very good exposure.

Program

The program mode (usually indicated by a "P") is similar to the auto mode but it usually allows you to exercise control over some camera settings (like white balance, ISO, etc.).

Shutter Priority

In this mode (commonly indicated by "Tv"), you select the shutter speed and the camera selects the best aperture setting to match the brightness of the scene. Choose a short shutter speed to freeze moving subjects, or a long one to blur them.

Aperture Priority

This mode is usually denoted by an "Av" on the exposure dial or menu. It allows you to select the aperture while the camera sets the shutter speed.

Manual

In this mode (indicated by "M"), you control all the settings, giving you complete control over the exposure.

Portrait

When shooting in the portrait mode (indicated by the profile of a face), the camera selects a wide aperture to keep the subject in focus while blurring the background. When shooting pictures of people, pets, and many other subjects, this can be useful. The background will grow progressively less distinct as you adjust the focal length toward telephoto (zoom in on the subject).

Landscape

In the landscape mode (usually indicated by a mountain and clouds icon), a narrow aperture is selected to keep as much as possible of the scene in focus. This can result in longer shutter speeds, so it's advisable to use a tripod to minimize camera movement. This mode works well for vast landscape scenes.

Night Portrait

The night portrait mode is usually denoted by a profile of a face with a moon and stars next to it. As was discussed on page 33, this mode is used to take a well-exposed image of a subject against a night scene. To do this, the camera's flash is used to illuminate the subject. The shutter speed, which is usually matched to the duration of the flash, is then left open a bit longer to allow the less powerful ambient light (light from the moon, street lamps, windows, etc.) to register in the image.

Artistic Effects

Often indicated by a palette and brush, this mode allows you to select from color options that may include shooting in black & white or sepia-toned as well as vivid color (enhanced color saturation and contrast) or neutral color (subdued color saturation and contrast).

Panoramic Mode

In the panoramic mode, the camera helps you create a series of slightly overlapping shots that can later be combined into one big image (see below). This can be done either horizontally or vertically. For more on this topic, see page 62.

Continuous

This mode is normally indicated by a stack of rectangles (photos) and lets you shoot successive frames for as long as the shutter button is pressed (until the camera or memory card runs out of memory.) This mode is perfect for hard-to-time action shots, like a softball player swinging at a ball (see pages 34–35).

Digital cameras are cool, but there are also lots of great images that have been (and will be) created on film. If you want to work with these on your computer, you'll need to digitize them—that's where scanners come in.

SCANNER BASICS

Scanning your images—whether they are prints, slides, or negatives—lets you take advantage of all the great tools your digital imaging software has to offer.

Even if you've totally embraced digital photography, the reality is that the vast majority of the images taken in the history of photography were taken on film (or some other non-digital medium). Your parents' and grandparents' wedding pictures, family baby pictures, photos from long-past vacations— all of these mean that film is still going to be with us for quite a while. Who'd want to give up on these treasures?

The good news is that, with a scanner, you can enjoy and share these images more easily than ever. You can also restore them to their original condition—something that would have been incredibly expensive before digital imaging came around.

Of course, a scanner is also great if you still want to use a film camera but get the benefits of digital imaging.

Types of Scanners

There are two basic types of scanners: one to digitize prints, and one to digitize slides and negatives.

Print scanners are often called flatbed scanners, because you place the print on a large, flat glass bed. With the image in place, an image sensor with a light unit attached to it moves beneath

Transparency scanners create digital files from slides and negatives. When buying, keep in mind the format of the images you want to scan. If you have non-35mm media (like large-format film, or negatives from antique cameras), you may need to purchase a special unit or an adapter. Some scanners accept only one format.

the glass and "reads" the photograph. Electronics then translate the data from the sensors into an image.

Transparency scanners are more expensive than flatbed scanners. However, because slides and negatives hold image detail better than prints, they also offer better quality. The two types of scanners work in much the same way— but with a transparency scanner, the light source is on one side of the film or slide and the image sensor is on the

GETTING CREATIVE

Prints aren't the only thing you can scan on your flatbed scanner—anything flat will work. Try leaves, flowers, decorative paper, fabric, etc. Just be sure not to place anything on the scanner glass that could scratch it!

other (i.e., the light shines *through* the film and hits the sensor).

Some scanners can digitize prints *and* transparent media. These look like flatbeds but also have a built-in adapter to hold slides and film, as well as a light to shine through these media onto the image sensor. If you have a variety of media to scan, this can be a good choice.

Resolution and Bit Depth

How much detail a scanner can record is determined by its resolution and bit depth.

The resolution of a scanner tells you how much data can be recorded by the image sensor. The number to look for is the optical resolution. This is the data that the scanner can actually capture without using software to enhance the pixel count.

The bit depth of a scanner determines how well it can differentiate between colors and shades of colors. Today's scanners provide great results for most photography; really expensive models, however, sometimes offer even more bit depth, which can be good for high-contrast images and slides.

Some flatbed scanners offer an adapter that allows you to scan transparent media. This feature usually costs a little bit more, but it may be worth it to you if you have a lot of slides or negatives in your image collection.

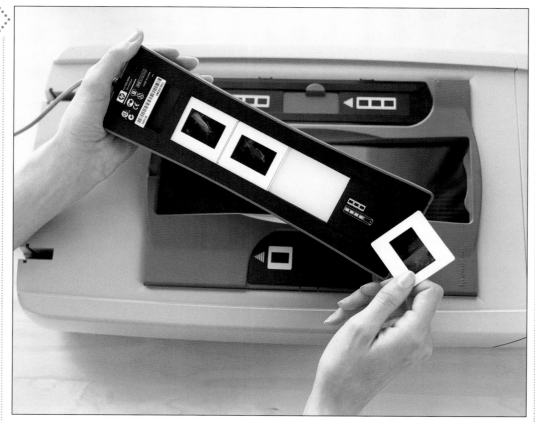

PREPARING TO SCAN

Scanning is as much an art as a science. It often takes a little trial and error to get just the results you want from a particular image— but it's worth the added effort to create a top-quality digital file.

In scanning, an ounce of prevention during the input process will be much better than a pound of cure. Correcting a poorly scanned image is rarely worth your time (and it's almost never 100 percent successful). It makes sense to select the best input method in the first place, and make every effort to avoid preventable flaws in the scanned image.

Dust

One very common, very preventable flaw is dust on the surface of the image. When scanning prints, invest in some dust-free cloths and wipe down the scanner glass and the surface of the image before every scan. For slides and negatives, use an antistatic brush and compressed air. While dust on prints can be pretty annoying, dust on slides and negatives can be a huge problem. Since the originals start out so small, when you enlarge your scan to the size needed to make a print (say, 8"x10"), you'll enlarge any dust particles along with the rest of the image data. A large spot of dust on a slide can actually obscure a significant area of the image!

So, yes, even though it may seem like a lot of trouble to go to, the few seconds you spend cleaning your photo-graph is nothing compared to the time it takes to remove hundreds of specks of dust from your digital image.

Some software products are available to help correct for dust in scans (because, despite your best efforts, there will usually still be a spot or two). Adobe Photoshop and Adobe Photoshop Elements, for example, offer a dust and scratches filter (for more on filters, see pages 72–73) to help eliminate problems. These do indeed work, but there can be a significant trade-off in image quality, so use them cautiously.

Resolution

Another pesky problem can be solved with a little extra attention to detail. Sooner or later you'll scan an image, spend hours perfecting it, and then realize you had the scanner set at too low a resolution. No matter how many times you've used the software, it pays to take a moment before each scan and review the settings to make sure you'll get what you want. For more on this, see page 50.

A Good Original

Finally, while the world of digital imaging offers a lot of opportunity to correct

flaws in images, you'll still be happiest when you start with the best-possible original. Sometimes there isn't a good original to scan (often, that's why we're scanning it to begin with). But, if you have a choice between two versions of the same image, scan the best one.

In general, it is easier to darken an image than to lighten one. When you start with a dark image and try to lighten it, you usually end up with shadow areas that are off color and too grainy. Therefore, if you have to choose between a *slightly* underexposed (dark) original and a *slightly* overexposed (light) original, you'll usually want to go with the overexposure. (If, however, the image is so light that there is no detail in the highlights, you'll still have a problem because there may not be any detail present to darken.)

Try Again

Finally, don't forget that you can always re-scan. When the first scan comes up on your screen, take a good look at it. Check out the resolution and examine the highlight and shadow areas to see if the detail you want has been captured. If you're not convinced it's the best scan you can get with your equipment, try again. Scanning is an art, and the more you use your equipment, the better you'll get at anticipating the results.

Auto scanner settings are sometimes problematic (left). Using custom settings can often improve your scan (right).

MAKING THE SCAN

Once you've picked the best original, cleaned it up, and dusted your scanner bed (whew!), it's time to—at long last—actually make the scan. But wait! There are still a few more decisions to make!

A lot of things have to go right to create a really top-quality scan—but most of them are pretty easy to figure out based on what you want to do with your image.

Determine the End Use

Before you even get started, you need to know how you want to use the scan you're about to create. Do you just want to e-mail a photo to a friend or put it up on a web page? Do you want to get a print made—and if so, how big do you want it to be? Will you be running the image in a newsletter? Or maybe you're planning to create a huge poster? The file you need to create will be different depending on the output you want.

Select the Right Resolution

Once you know how you want to use your image, you should be able to figure out what the resolution needs to be. For e-mailing or web-page viewing, 72dpi will do the job. To make a print at a lab, you'll probably need about 200dpi. To print your image in a color news-letter or as a poster, you might need 300dpi. If you will be printing the image, consult your printer's manual to see what it recommends; if you'll be hav-ing the image printed professionally, ask the lab or print provider for their exact specifications.

Select the Scale

With slides and negatives, you'll almost always want to enlarge the image from the original (unless, perhaps, you are designing a postage stamp). With prints, too, the whole reason for scanning them may be to get a larger picture from an image when the negative has been lost.

If, for whatever reason, your final image needs to be at a different size than the original, you should determine that now. If in doubt, guess bigger than you think you'll need. If you need to reduce the size of the image later, you won't encounter any significant reductions in image quality. If you guess too small, though, you may need to redo the scan; image-editing software just isn't all that good at adding pixels to an image. For more on this, see pages 12–13.

Let's imagine you are starting with a 4"x5" print and you want to make an 8"x10" print. How much would you need to enlarge it? Well, you want to double the size, so you'd set the enlarge-ment to 200 percent. For a 5"x7", you'd set it to 140 percent, etc. (If this

seems confusing, see if your scanner software lets you set a "target" or "final" size—then you can just type in the dimensions you want the final image to be.)

Other Settings

Most scanners offer additional settings that you can choose to use.

For example, you may be able to sharpen your images. Most scans do need a little sharpening, so this can be a good thing. Try it out and see if you're happy with the results. (You can also sharpen your images using your image-editing software, a method that provides much greater control—see pages 92–93 for more information on this.)

You may also be able to specify whether you want to create a color or black & white scan. How you set this will depend on your original image. Keep in mind that you can always convert a color scan to black & white later on using your image-editing software (see pages 78–79), but you can't really go the other way.

Most scanners also give you some color and tonal adjustment tools. These vary widely by model, so check your manual to see if these tools will work for you and enhance your results.

Check the Settings

When you're doing a series of identical scans, it's easy to forget to check the software settings, but it pays to do it *every* time. If you don't you'll eventually discover that the resolution got set back to 72dpi, or the scale is wrong, or *something*. That can be one incredibly frustrating experience!

WHEN IT'S TIME TO CALL IN THE PROFESSIONALS

Scanning, as you have probably figured out, can be pretty time-consuming, and getting the best-possible results really does require good equipment and some experience. Fortunately, there are lots of ways to get scans made quickly and, usually, at pretty reasonable costs. These can be especially useful when you have a lot of images to scan (say, a whole slide collection). With automated equipment, the pros can scan a whole bunch of images in the time it takes you to do one—and wouldn't you really rather be out taking more pictures anyway?

Professional scans, returned to you on CD, can be obtained at most photo labs (even some mini-labs in grocery and drugstores now offer them). You can even drop your exposed film off for processing and get back both prints and a CD. At many online labs, when you send your images in for processing, they will return your prints and automatically place scanned versions of your images in a password-protected site so you can download the files you want, e-mail them to friends, order reprints, etc.

For more professional needs, there are top-quality scanning service providers all over the country (and the world, for that matter) whose experienced technicians know how to draw the best out of every image. Check your phone directory or look online for these services. If you decide to take this route, be sure to check out the prices at a few different suppliers, because they can vary widely from company to company.

Hardware

In the world of digital imaging, your desktop (or laptop) computer is your darkroom. It's where you'll process and review all your photos, make any needed changes and refinements, and prepare the files to print or share online.

COMPUTERS

The work you do with your images on your computer is absolutely critical—so it pays to have a system that will work with you and not fight you every step of the way!

In the world of digital photography, your computer plays a central role. Without it, you couldn't really take advantage of all the great opportunities digital imaging affords.

The good news is that the same computer you use to read your e-mail, write sales reports, and buy books online will probably work just fine.

The following are some tips for ensuring you have what you need.

Platform

Does it matter if you work on a PC or a Mac? Although users of one system or the other may have their personal loyalties to their platform of choice, it really doesn't matter that much. What's more important is that the system you use has the speed, memory, and other qualities that make it efficient and reliable to use—and, above all, that you are comfortable using it.

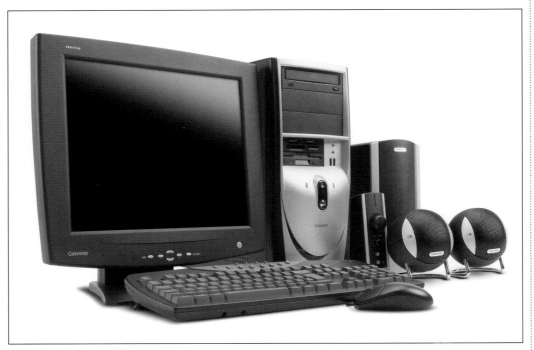

Windows-based PCs are popular in the business world, so they are many people's first choice when purchasing a home computer.

Macintosh computers tend to be favored by students and professionals who work in creative fields like photography and graphic design.

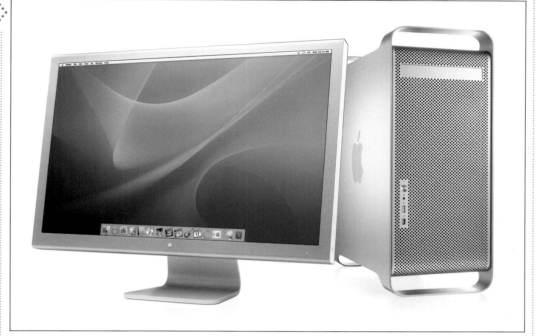

Speed

Manipulating an image requires your computer to do a lot of fancy math—so you'll want to make sure it can do so quickly. Unfortunately, getting the real low-down on this can be tricky since the methods used to calculate speed vary and make clock-speed comparisons irrelevant. The best approach is to check out the software you want to run and make sure the computer you own (or plan to buy) has sufficient speed. Most current systems are more than adequate.

Memory

RAM. This is the memory your software and images are loaded into when you open them. If you have too little, things will get *really* slow. Again, check your software to determine its minimum requirements—and add more RAM if you need to (it's actually quite cheap!).

Hard Drive. A big hard drive is ideal, since image files can take up lots of space. Something in the 60GB to 80GB range is great, but you can get away with less if you need to.

FOR PHOTOGRAPHY ON THE GO

How many memory cards do you really want to buy? For long photography expeditions, a laptop will serve you well. In addition to giving you a quick way to upload your photos, you can use the laptop's CD/DVD burner to make daily backups of vacation photos—and get online to e-mail pictures back home.

MONITORS

How big should it be? Is a flat-screen LCD better than my old CRT monitor? What the heck is a dot pitch? There's a lot to consider when choosing a monitor—and the answers are pretty important.

Your monitor is the primary visual component of your computer. If, like many who get into digital photography, you become semi-obsessed with refining your images, you're going to spend a lot of time looking at it.

Color and Quality

One of the primary concerns when it comes to selecting a monitor is how well it represents color. This is obviously more important for digital photography than for, say, word processing. In addition, you should consider the quality of the picture. It's especially important to check the edges of the viewing area to see if the image looks fuzzy or distorted. If so, move on to another model.

Size

Monitors increase exponentially in price as they get bigger. For most people, a 17" monitor is about the smallest that is comfortable for digital imaging. In part, this is due to the fact that most image-editing programs feature a number of screen-area-consuming palettes that reduce the amount of viewing space for your image.

Also, with CRT models (see facing page), a "17" monitor" may not actual-

ly have 17 inches of viewing area; the viewable area may be one to two inches smaller. Most specifications for monitors list the viewable area, so look for this listing.

If you can afford it, a really big monitor is great—but be aware that really big monitors require really big desks!

Resolution

Virtually every monitor can support 640x480 pixel resolution (also called "VGA" resolution). In order to display more information on screen, most mod-

Flat-screen LCD monitors are the latest in viewing technology. They offer some advantages but still come with a pretty steep price tag.

CRT (Cathode Ray Tube) monitors are the most common type. Although their prices are pretty friendly, they do have some drawbacks—one of which is their sheer size, which can eat up a whole lot of desk space.

els also offer at least one "Super VGA" setting—often 800x600 or 1600x1280 pixels. High-end monitors offer settings at even higher resolutions.

Refresh Rate

High refresh rates (or, on LCDs, pixel response times) help reduce screen flicker, which in turn reduces eye strain and (in some people) headaches.

Dot Pitch

This measurement is used to determine how sharp the display of a CRT monitor is. The smaller the number, the finer the picture. Most monitors have a dot pitch between .25mm and .28mm. On a very large monitor, a higher dot pitch (in the .30mm range) will still produce a pleasantly crisp image.

LCD OR CRT?

CRT monitors are the most popular type on the market, but LCDs are gaining ground. What's holding people back? Probably the price; LCDs are still a lot more expensive than CRT monitors of the same size. There are benefits to LCDs, though, so as prices drop, they will likely become more popular.

First, LCD monitors take up a lot less space and are much easier to move. A big CRT can weigh 100 pounds while its LCD counterpart will check in at something under fifteen.

LCDs require less power—which in a time of rising electric bills is an important consideration.

The flat, nonreflective screen of the LCD reduces eye strain. Here, the low-end CRT models take a double hit: with their curved, shiny screens, glare and distortion can be a real problem. (High-end CRTs do offer nearly flat screens that reduce glare and distortion, however.)

LCDs also offer good color fidelity and a larger on-screen viewable area.

Are there problems? Sure. LCDs have lower refresh rates than CRTs (although this will change as the technology evolves). They also tend to have lower resolutions than CRTs. You should also watch out for "dead" pixels—dots on the screen that stop responding. Make sure this problem is covered by your monitor's warranty.

USEFUL ADDITIONS

You can definitely do digital photography with very minimal equipment—but if you're a gadget freak, there are a wide variety of tools and accessories that can make your life a little easier.

Once you've set up a computer work station with some kind of image-editing software, you can certainly leave it at that. If you want to spend a little more to add functionality and make your life a bit easier, the following are some good investments.

Extra Storage Space

Digital photographers tend to take a lot of pictures. Depending on the size of your computer's hard drive(s) and how much you shoot, you may need a little extra real estate to store your images. Adding an external hard drive can create that space. It is especially convenient for archiving images that you want to have easy access to. You should still back up all your images to CD or DVD, of course. After all, hard drives *do* crash from time to time—and sometimes in spectacular data-munching ways.

Card Readers

Most cameras allow you to upload your images by connecting your camera to your computer via a cable. Most people find it's actually easier, though, to use a card reader. Simply pop your memory card out of the camera and into the card reader (just like you would a floppy disc)

External hard drives are now quite reasonably priced and can add a lot of extra storage space to your computer system.

For many people, using a card reader to transfer images from their digital camera to their computer is a lot easier than having to attach the camera to the computer with a cable each time.

Using a graphics tablet lets you control your cursor more precisely than with a mouse—a great asset for detailed image retouching.

and copy the files from the card onto your hard drive. Most card readers connect via a USB or FireWire port. If your computer is FireWire equipped, this will provide the fastest rate of data transfer (minimizing the amount of time you sit waiting for your images to copy over). When buying, you should also make sure that the reader you select is designed for the format of card you use. Some readers accept only one type; others are designed for multi-format use.

Graphics Tablet

For really detailed image retouching, most people find it hard to get the level of precision they want with a regular mouse. The graphics tablet allows you to move your cursor around using a pen-shaped stylus—essentially allowing you to "draw" on the screen. Great for digital painting and drawing, graphics tablets are also pressure sensitive—as with a real pen or paintbrush, pressing harder creates a wide, dark line; light pressure creates a thin, light line. Before investing in a graphics tablet, check your image-editing software to ensure it supports their use.

CD/DVD Burner

Okay, this is really a necessity—but if you have an older computer with a slow CD burner, you might want to consider adding a faster one or a DVD burner. You'll be making a lot of backup discs, so it makes sense to do so efficiently.

Internet Connection

The Internet is a great source of information on digital imaging—including product reviews, tips, techniques, user forums, and more. You can also download updates and plug-ins for your digital imaging software. Additionally, an Internet connection allows you to connect to online labs to print your photographs or set up digital albums. You can also use your connection to e-mail photos to your friends and family.

Scanner

Refer to chapter 5 to see if a scanner would provide functions you need.

Printer

While printing at a lab is cheaper and produces better results, a good inkjet printer is a nice thing to have for quick prints, adding photos to letters, and other day-to-day tasks.

Here's where things with digital imaging really start to get fun and creative! With even basic image-editing software you can make almost any photograph look a whole lot better—often with just a few minutes of work!

CONSUMER LEVEL

Basic image-editing software is now available at a price almost anyone can afford—you may even find a program packaged with your camera or scanner!

There are basically three categories of image-editing software. These are divided by the overall functionality, the intended user, and the selling price. We'll begin with consumer-level products. These offer surprisingly high image-editing capabilities, are usually designed for hobbyists, and normally retail for up to $100 (and many are actually much cheaper).

Adobe Photoshop Elements

Elements is probably the most highly functional of the consumer-level image-editing programs—and it comes with a very friendly price tag, selling for just about $90. That's actually a bargain, though, when you consider that it offers all but the most professional-level tools found in Adobe Photoshop (its big brother) but for about $500 less. The wide availability of books and other supporting materials available for learning Elements also makes it a good choice for many beginners. Additionally, if you are serious about digital imaging and may want to move on to working with Adobe Photoshop at some point in the future, the Elements interface is almost identical, so you'll have a head start. Packed with powerful tools for retouch-

ing images, creating panoramics, adjusting color and exposure, adding special effects, and much more, Elements is a great multipurpose image-editing tool. To learn more, visit www.adobe.com.

Roxio PhotoSuite

Retailing for about $30, PhotoSuite offers tools for quickly correcting common photo problems and adding special creative effects. Additionally, you can create slide shows with special transitions between images, music, narration, and captions. A tool is also offered that allows you to fix multiple photos at the same time. To learn more, just go to www.roxio.com.

Ulead PhotoImpact

A bit higher on the food chain, PhotoImpact sells for around $90 and allows for the correction of common problems. You can also add artistic effects, text, graphics, and painting to your images. PhotoImpact provides a host of tools designed for those planning to use their images on the Internet, including web animations, web-page design tools, and the ability to design interactive digital photo slide shows. For more information, visit www.ulead.com.

Hijaak Digital Photo Studio

Digital Photo Studio, retailing for around $50, lets you enhance your images with the help of their "Image Wizard"—software that walks you step-by-step through common image-editing tasks. In addition to performing all the functions you'd expect (cropping, exposure and color correction, special effects, etc.), Digital Photo Studio accepts over 65 different file formats. To learn more, visit www.hijaak.com.

Microsoft PictureIt!

PictureIt!, which sells for about $50, also includes tools to walk you through common jobs. Additionally, you'll find quick tools for enhancing lighting, correcting the color and composition of your images, and restoring old photos. The "MiniLab" allows you to correct batches of photos at the same time. Pre-created templates (1500 of them!) are included to help you put your photos to good use in cards, frames, calendars, and other photo projects. For further information, visit www.microsoft.com/products/imaging.

Jasc Paint Shop Pro

For about $100, Paint Shop Pro offers a complete, all-around image-editing package that's just about on par with Adobe Photoshop Elements (although fewer books and supporting materials are available). For more information, visit www.jasc.com

Kai's Photo Soap

Retailing for only $20, Photo Soap is a quirky program with a totally unique interface that you'll either love or hate. It's hard to beat the price, though, for a program that lets you correct all the common problems, add special effects, create photo projects, organize your photos, and more. For additional information on this product, visit www.scansoft.com/photosoap.

ACDSee

ACDSee provides automated and manual tools for enhanced control over your images. Selling for $50, it's a popular program with lots of loyal users. Visit www.acdsystems.com for more details.

Picture Window Pro

Produced by Digital Light and Color and retailing for about $90, Picture Window Pro offers a comprehensive set of image-editing tools. Useful software is also included to help you create digital photo albums. For additional information, see www.dl-c.com.

TAKE A TEST DRIVE

Even low-cost image-editing software isn't a bargain if it doesn't do what you want it to or has an awkward interface that you don't enjoy using. Rather than just buying the software off the shelf, it's a good idea to check out the manufacturer's web site. There, you'll find much more extensive detail than on the product packaging—and you may even find a trial version you can download and test out. Usually, these trial versions have all the features of the full version, but they don't allow you to save your work. They are also set to expire (cease to function) after a certain number of days or uses. This is a great way to get a sense of whether or not the product is worth your money.

PROFESSIONAL LEVEL

Photoshop and Painter both have a hefty price tag, but their amazing functionality and solid history have made them the choice of professionals for years.

Adobe Photoshop and Corel Painter are serious programs that make it possible to accomplish truly complex image-editing tasks.

Adobe Photoshop

Adobe Photoshop is the granddaddy of image editing programs—and it commands a steep price (about $600).

The program has its origins in 1987 when Thomas Knoll, a PhD. candidate in Ann Arbor, MI, was studying the processing of digital images and became dissatisfied with the inability of his computer to display grayscale levels (the tones between black & white in a digital photograph). He began writing software to fix this (and other) problems.

This computer wizardry caught the attention of his brother John when he paid a visit to Ann Arbor on vacation from his job at Industrial Light and Magic (the visual-effects masters behind films like *Raiders of the Lost Ark* and *The Empire Strikes Back*). It struck him that the work his brother was doing was similar to the image processing tools he had recently seen demonstrated on the Pixar image computer.

Shortly after, the two pulled together a product called "Display." Although

Adobe Photoshop is the industry standard for image editing.

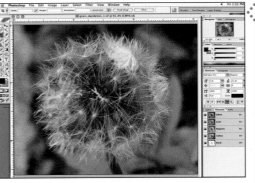

The Adobe Photoshop work space.

they were initially unsuccessful in marketing the product, one company finally agreed to package the software (as "Photoshop") with their scanners in a limited run. Only two hundred copies of the program sold.

In 1988, the Knoll brothers finally had a turn of good luck when they sent

a demo to Adobe's creative team. After ten months of creative development, Photoshop 1.0 shipped early in 1990, followed by version 2.0 later in the year.

In the years since, Adobe has continued to make huge updates. Driven by advancing technology and responsiveness to feedback from creative professionals, Photoshop has remained on the cutting edge of digital imaging. It's quite simply the industry standard in graphic design and photography.

What makes Photoshop so great? The simple answer is control. Photoshop offers you more ways than any other program to get into your images and totally perfect them. If you want to take total control over your digital images, you simply can't do better. For more information, visit www.adobe.com.

Corel Painter

Selling for about $260, Corel Painter is the image-editing program of choice for those interested in artistic effects and creating "painterly" images from their photos. It is, without a doubt, the leader when it comes to natural media painting software.

While Painter is very popular, it has had a somewhat rocky history. It began its life under the name "Fractal Design Painter" in 1991. Later, it was sold for several years by the MetaCreations Corporation. When MetaCreations decided to specialize in worldwide web applications, the future of Painter suddenly became unclear. Fortunately, and to the relief of its many devoted users, Corel stepped forward in 2000 and purchased the rights to the program.

Corel Painter is the leader in natural media painting software (top). The Painter work space is shown in the bottom photo.

Two versions later, the program has clearly benefitted from Corel's investment in developing the software. With some practice (and a graphics tablet—basically a necessity for fluid painting [see page 57]), it's actually pretty easy to create a nice work of art from your photograph. With a *lot* of practice and some good aesthetic sensibilities, you can create natural-looking paintings, watercolors, and other works of art that are truly dazzling. For more information, visit www.corel.com.

SPECIALIZED

If you can dream it, someone has probably come up with a piece of software that is designed specifically to do it—and probably do it really well!

Check out any big software store and you'll see the shelves covered with hundreds of software products designed to make your images prettier, turn them into greeting cards, group them into interactive albums, set them to music, share them online, and much, much more. The following are some common types of specialized software.

Image Stitching

Several programs are available to help you turn a sequence of individual images into one gigantic one. PhotoVista Panorama from iseemedia (www.iseemedia. com, $70) is one such program; its sole function is the creation of panoramic images. PhotoVista 3D, also from iseemedia ($100) works on a similar principle, except it allows you to create a sequence of images that show a subject from all angles, then combine them into a 3-D image of the object that you can pick up and rotate on screen.

Special Effects

Some imaging programs are devoted to special effects. A good example of this is Kai's SuperGoo (www.scansoft.com, $20), which "liquifies" your image and allows you to smear, warp, and stretch it. You can even create an animated movie of the process—or add fake hair, eyes, noses, and more to your subjects from a library of facial components.

Digital Albums

One of the most popular types of digital imaging software allows you to create virtual "albums" to be viewed on screen

Image stitching software is designed to seamlessly blend a series of individual images into one big one.

Adobe Web Photo Gallery

Adobe Photoshop Album lets you create web albums using pre-designed templates.

or printed out. Some even let you create a DVD of your album that will play on your home theater system. Adobe Photoshop Album (www.adobe.com, $50) is popular, as is Flip Album (www.flipalbum.com, $20).

Greeting Cards

There's a whole lot of greeting-card software on the market, so if you're interested in making your own, you're sure to find a product that suits your needs. Packages of templates are available for funny cards, inspirational cards, all-purpose cards, etc. Nova Development (www.novadevelopment.com) has several packages, including Greeting Card Factory Deluxe, which retails for about $50.

Calendars

Some of the programs used to create cards also let you make calendars using your own photos. The Print Shop Deluxe (www.Broderbund.com, $50) is one such program. It includes thousands of templates for a variety of projects.

Image Enlargement

Programs like Extensis pxl SmartScale (www.extensis.com, $200) allow you to greatly increase the size of your images without any visible loss of quality.

Sharpening

Sharpener Pro ($80–$330) from nik multimedia lets you sharpen your images while tailoring your results to your intended method of output—whether it's online, an inkjet printer, or a fine-art book. For more information, visit www.nikmultimedia.com.

PLUG-INS

Believe it or not, even if programmers stopped creating new plug-ins today, there would still be enough on the market for you to try a new one every day for many years.

There are literally thousands of plug-ins on the market, yet most digital photography enthusiasts have never even heard of them! Once you scratch the surface, you can quickly get hooked on the neat little programs (which also, thankfully, tend to be inexpensive).

What are Plug-ins?

Plug-ins are small programs that run from within a major application (like Adobe Photoshop) and are used to add a narrowly specialized function. Because of the prominence of Photoshop, most digital imaging plug-ins are written in a Photoshop-compatible format. You don't *have* to use Photoshop, though; many other imaging applications (including Photoshop Elements) accept Photoshop-compatible plug-ins.

What Do They Do?

Plug-ins can do all sorts of things: help you correct exposure; reduce grain in your images; correct for lens distortion; simulate traditional on-camera photo filters; add artistic effects; simulate wind, rain, and snow . . . the list goes on! Probably the most popular plug-ins are used to add creative special effects and specialized borders. On the facing page is a series of images created with plug-ins from nik Multimedia. Designed for photographers, the Color Efex Pro! package features over fifty filters (see pages 72–73) that create effects ranging from subtle to extreme. See the contact information below for more details.

WHERE TO FIND PLUG-INS

Type "Photoshop plug-ins" into any Internet search engine and you'll probably get more hits than you can surf through. The following are some of the top plug-ins manufacturers:

Adobe
www.adobe.com/support/downloads

Alien Skin Software
www. alienskin.com *and* www.macromedia.com/downloads

Applied Science Fiction
www.asf.com

Auto FX Software
www. autofx.com *and* www.autofx.com/freeplugins

Corel
www. corel.com

Extensis
www. extensis.com

Flaming Pear Software
www. flamingpear.com *and* www.flamingpear.com/download.html

Human Software
www.humansoftware.com

theimagingfactory
www.theimagingfactory.com

LizardTech
www.lizardtech.com

nik Multimedia
www. nikmultimedia.com

The Plugin Site
www.thepluginsite.com

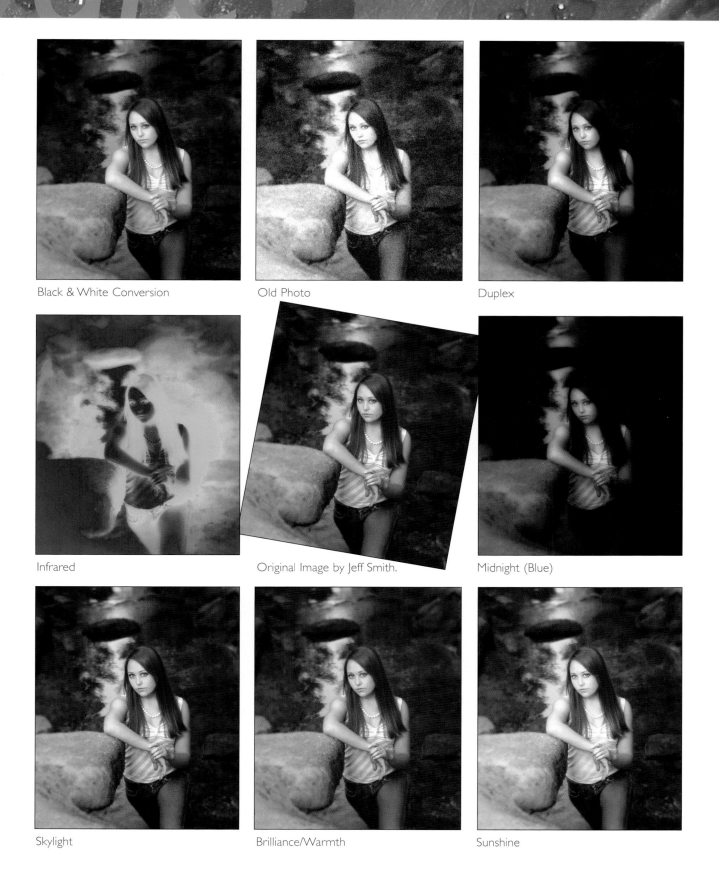

Black & White Conversion

Old Photo

Duplex

Infrared

Original Image by Jeff Smith.

Midnight (Blue)

Skylight

Brilliance/Warmth

Sunshine

Enhancing Images

With digital imaging, taking the picture is just the beginning—the real magic happens when you get to your computer and begin finding ways to refine your vision and create the strongest possible photograph from your original.

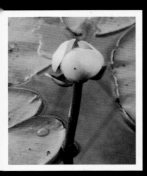

INTRO TO ELEMENTS

The first step to making great images is learning your way around your image-editing software. Here, we'll be using Adobe Photoshop Elements.

It would be impossible to include instructions for every image-editing program on the market in just one book. Therefore, the techniques described in this chapter are based on Adobe Photoshop Elements. This is one of the most popular image-editing programs among serious non-professional photographers. If you prefer to use another program, you'll find that the basic techniques remain the same; the names of particular tools and menu items may, however, be a bit different.

Menu Bar

The Menu bar runs across the very top of the screen and contains a number of pull-down menus. These are used to open and close files, rotate and resize images, and to access the tools that will help you enhance your images. From the Help pull-down menu, you can access the various help features to rescue you when you really get stuck.

Shortcuts Bar

Directly under the Menu bar is the Shortcuts bar. On it are one-click icons for opening and saving files, printing, and more. There's also a search feature—just type in the term you want to look up, hit Search, and Elements will look for it in its help files.

Palettes and Palette Well

At the far right side of the screen is the Palette Well. It looks like a series of file folder tabs, each labeled with the name of a palette. To open a palette, just click on the file tab and the palette will drop down from it. The palette will automatically snap closed as soon as you click anywhere else on your screen.

By default, the free-floating Hints and How To palettes are open on the right side of the screen. You can move them by clicking and dragging on the top edge of the palette.

Options Bar

Beneath the Shortcuts bar is the Options bar. This bar changes depending on which tool is selected, allowing you to customize the function of that tool to your liking.

Tool Bar

At the far left of the screen is the Tool bar. This contains all of the tools you'll need to refine your images—like the Crop tool, Brush tool, Clone Stamp tool, Marquee tool, and more. To the

Elements Tool Bar

Marquee	Move
Lasso	Magic Wand
Selection Brush	Crop
Custom Shape	Type
Paint Bucket	Gradient
Brush	Pencil
Eraser	Red Eye Brush
Blur	Sharpen
Sponge	Smudge
Dodge	Burn
Clone Stamp	Eyedropper
Hand	Zoom
Foreground color	Switch foreground and background color
Set foreground color to black, background color to white	Background color

left is an overview that you may wish to refer back to as you work through the various techniques.

Zoom Tool

To "zoom in" on your images (enlarging your view), click on the Zoom tool, position it over the area you want to zoom in on, and click one or more times. To zoom out, hold down the Alt/Opt key and click one or more times. To see the whole image on screen hit Cmd/Ctrl + 0 (zero).

Mistakes

If you notice right away that you don't like what you just did, go to Edit> Undo. This will reverse the last thing you did, but *only* the last thing.

The Undo History palette, on the other hand, records each change you make to an image. Steps are listed from the top down, so the first thing done to the image is at the top of the list, and the most recent is at the bottom.

By clicking on the states in this time-line, you can move back and forth through the history of the image and compare previous versions to the current one, or to undo the last ten steps.

When you close an image, all of the saved states will be deleted, so be sure you're done with them before you close your image file!

Hints and Help

Elements comes packed with lots of help for beginners. Make use of the Hints and Help palettes when you have problems or questions, or just need a tip.

BASIC OPERATIONS

This section covers two basic operations you'll need to know to follow along with the techniques in this book. Don't hesitate to refer back to it as you explore the following lessons.

Using layers and selections allows you to work on discrete areas of your image. This allows you to make very detailed refinements.

Layers

Layers are like sheets of clear plastic, laid one on top of the other. Each layer can be accessed, worked on, moved, or deleted independently of any other layer. This is great for trying out effects, since you can simply discard the layer if you don't like the results.

Layers are created, accessed, and manipulated via the Layers palette. If this is not visible on your screen, go to Window>Layers. The window will appear in the Palette Well, but you can drag it onto the desktop. Many features connected with the use of layers can be accessed directly from this palette. Other features for using layers are accessed via the Layers pull-down menu at the top of the screen.

The main feature in the Layers palette is the list of layers. These are stacked from bottom to top. The background layer (usually the photograph you opened) is the bottom layer and the layers that overlay it rise one after another to the top of the palette.

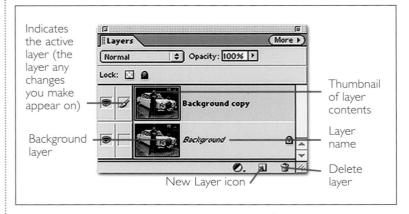

Indicates the active layer (the layer any changes you make appear on)

Background layer

Thumbnail of layer contents

Layer name

Delete layer

New Layer icon

When you open a photo, you'll see one layer: the background layer. In many of the step-by-step techniques that follow, you will be asked to duplicate this background layer. To do this, go to the Layers palette and drag the background layer onto the New Layer icon at the bottom of the palette.

Another way to create a new layer is to select some or all of an image (see below), then copy (Edit>Copy) and paste (Edit>Paste) it. The pasted area will automatically appear in a new layer. Using the Text tool (see pages 90–91) will also add a new layer.

To delete a layer, drag it into the trash can at the bottom of the Layers palette. This will remove the layer and any data on it. To get rid of all of your layers while preserving the data on

them, go to Layer>Flatten Image. This will composite all of the layers down into one—preserving everything you've added.

If you want to save your layers so you can work on them later, save the file in the PSD (Photoshop document) format. If you need to use another file format, like JPG or TIF, you can always save a copy by going to File>Save As.

Selections

The selection tools allow you to isolate individual areas that need work and apply your changes to only those areas.

When using selection tools, the areas you have selected are indicated by a flashing dotted black & white line (often called "marching ants") around the area. The simplest way to make a selection (of your whole image) is to go to Select>All.

When you make a selection, you are telling Elements that the changes you are about to make should apply only to that area of the image. When you want to move on to change another area, select the Marquee tool and click on your image to deactivate the current selection.

Try this just to see what the selection indicator looks like.

The selection tools also have unique Options bars (see page 66) that allow them to be customized for each task. As you start to explore these tools individually, be sure to keep an eye on these settings—they can make the process of creating a selection much easier.

The Marquee tool (see the Tool bar on page 67) is used to make rectangular or elliptical selections. In the Tool bar, click and hold on the Marquee tool icon to make both options visible. Select the tool that best matches the shape of the area you want to select, then click and drag over the desired image area to select it. You'll probably need to practice this in order to end up with the selection exactly where you want it in your image. This is especially true with the Elliptical Marquee tool, which can be tricky to master. (Instead of drawing the shape from its edge, you can draw it from the center by holding down the Alt/Opt key before you click and drag.)

To select a perfectly square or perfectly round area, select the Marquee tool (either rectangular or elliptical), hold down the Shift key, then click and drag over your image.

Another very useful tool is the Magic Wand, which allows you to select an area based on its color. We'll be using this on pages 86–87.

Note: Once you have made a selection, *do not* click anywhere else on your image with a selection tool unless you want to deactivate (eliminate) your selection. If you accidentally do this, use the Undo Histories to reactivate it.

DUPLICATE AND ROTATE

Some pictures need almost no help to make them really terrific; others need quite a bit. Fortunately, digital photography means you never have to settle for "okay."

Whether you've scanned the image or shot it on your digital camera, your first step should be to determine that the file is of the size and resolution you need for the output you intend. To check this, go to Image>Resize>Image Size. Take a look at the data there and make sure it's at least as big as you need (if it's bigger, you're fine; if it's too small, you may need to reconsider how you want to use your image).

Duplicate

If you've just scanned an image or just imported an image from your digital camera, it's an extremely good idea to make a duplicate of the original before you begin manipulating it in Elements. You may think you won't make any mistakes—but, like the rest of us, sooner or later you will. And when that mistake is accidentally saving an edited version of an image over the one and only original, it can be pretty frustrating—especially if

In the Duplicate Image box you can rename the new image or leave the suggested name (your original image name plus "copy") in place.

USING RECIPES

The recipes in the How To palette are step-by-step instructions for accomplishing a wide range of common imaging tasks. To open this, go to Window>How To. To use a recipe, select one of the categories from the Select a Recipe pull-down menu at the top of the palette. When you do this, the list of recipes in that category will appear and you can pick the one that seems to best suit your needs. You can also preview the steps before starting to make sure you know how to do everything.

you wanted to try some other effects on that original before deciding which you liked best.

To quickly make a backup of your image, you can simply go to Image>Duplicate Image. In the dialog box that appears, you can rename your duplicated image or use the suggested name (which will be your current file name plus the word "copy"). When you hit the OK button, a duplicate image window will appear in the Elements workspace. This will be the copy of your original image, and you can begin working on this copy

To take a vertical photo, you tilt your digital camera. When these images are transferred to your computer, they will, however, appear as horizontals (above). To get the proper orientation, just rotate them 90 degrees to the left or right (right).

without altering your original. This procedure also works well when you are in the process of working on an image and want to compare the before and after versions side by side. Just duplicate the "before" image, make your change on the copy, then position the images side by side on your screen and decide which one you like the best.

Rotate Image

Under Image>Rotate, the top portion of the drop-down menu contains options for rotating your image. When you shoot with a digital camera, this is the function you'll use to properly orient your vertical images (the ones shot with the camera turned on its side). Depending on the image, you can decide whether it needs to be rotated 90 degrees left or right. You can also rotate it

180 degrees—useful if you scanned it upside down (or shot it upside down during your trapeze lesson).

You can also flip your images horizontally or vertically. This can be useful when scanning slides or negatives, which are easy to flip the wrong way in the scanner.

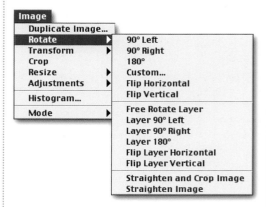

Under the Image menu, you can duplicate or rotate your image.

FILTERS

Sometimes the name of a filter doesn't tell the whole story. When you're experimenting with filters, be sure to try extreme settings (both high and low). What happens might pleasantly surprise you.

A filter is a specialized piece of software that runs within Elements and is used to apply a specific effect to an image. Many filters are packaged with Elements itself, and other filters (from Adobe and other companies) are also available to meet specialized needs.

You can apply filters by going to the Filter pull-down menu at the top of the screen. Pulling this down will reveal several submenu categories that contain the individual filters. Select any filter to apply it. Some will apply immediately, some will open a dialog box in which you can customize the settings.

To simplify things, the filters are grouped according to the basic look they provide—like "artistic" or "sharpen" or "texture."

The filters in the Artistic group are designed to imitate the effects of traditional artistic media.

The filters in the Brush Strokes group can be used to add the look of natural brush strokes to an image.

The Sketch filters imitate the look of the various media used in sketching, as well as some other paper-based artistic processes.

The Blur filters let you reduce sharpness in an image. This can be useful for creating a soft-focus effect or for adding special effects (like a motion blur). See pages 92–93 for more on this.

Original image

Pointillize filter

Lighting Effects filter

Watercolor filter

Sumi-e filter

Spherize filter

Chalk and Charcoal filter

Diffuse Glow filter

Find Edges filter

The filters in the Distort menu add waves and other shape-changing effects to images.

The Pixelate filters break the image into clumps—circles, squares, and other patterns.

The Render filters produce some special 3-D shapes, clouds, refraction patterns, and simulated light effects. These are mathematically intensive filters and may take a while to apply to your image, so be patient.

The Sharpen filters allow you to correct minor focus problems and restore sharpness after scanning an image. See pages 92–93 for more on this.

The Texture filters, as their name implies, add the look of a textured surface to your images.

The filters in the Stylize group can create some very interesting looks. You won't use them every day, but they are a lot of fun. The best way to see what they do is to give them a try.

COLOR AND CONTRAST

Making color look right is challenging, but it's probably the most important thing you can do to make your images look their very best.

If you've ever had the experience of developing or printing either color or black & white images in a traditional darkroom, you know that getting the tones in your images just right can be a laborious task. With the automatic image-correction functions in Elements, however, it's amazingly simple to create dramatic improvements.

That's the good news. The bad news is that Elements is, after all, a piece of software—it's not equipped with human vision. To compensate for this short-coming when making its automatic corrections, it is forced to assume what the image is supposed to look like.

Elements assumes, for instance, that you want there to be at least a small very dark area and a small very light area. This is, in general, characteristic of a well-exposed image with good contrast. If you are working with a softly lit photo of a tree in dense fog, however, this assumption isn't going to make your image look very good at all.

The software also makes assumptions about the overall lightness and darkness that an image should have and about how the colors in the image should be balanced. When your images match these assumptions (and many

Enhance	
Quick Fix...	
Auto Levels	⇧⌘L
Auto Contrast	⌥⇧⌘L
Auto Color Correction	⇧⌘B
Adjust Lighting	▶
Adjust Color	▶
Adjust Brightness/Contrast	▶

Go to the Enhance pull-down menu to access the auto correction features.

photos actually do—they didn't pull these assumptions out of midair, after all), you are likely to get pretty good results—maybe even great ones—from the auto functions. When your photos don't match these assumptions, however, the results achieved with the auto functions can be pretty scary.

That said, it only takes a couple of seconds to figure out if these methods will give you the results you want, so it's almost always worth giving them a try. Just be prepared to hit Edit>Undo if you aren't happy with the results.

Auto Contrast

The Auto Contrast command, as the name implies, adjusts the contrast of your image—and only the contrast. It will not help any color problems that might be present in your photograph. If the contrast in the image you are working with seems a little flat or dull but the

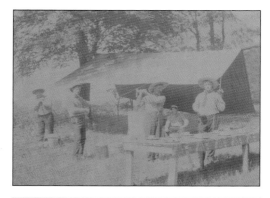 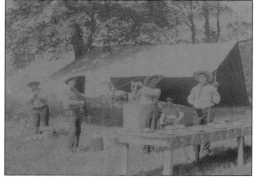

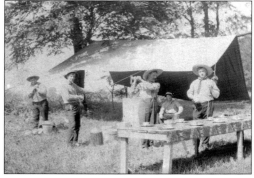 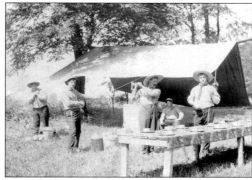

The original photo (top left) lacked contrast and had a yellow color cast. The Auto Contrast (top right) helped the contrast but not the color. The Auto Levels (bottom left) improved both the color and contrast, taking the image to a sepia tone that is probably close to what it originally looked like. The Auto Color Correction (bottom right) fixed the contrast and eliminated the color cast, rendering the photo in pure black & white tones.

color looks okay, this would be one strategy you could try.

Auto Levels

Auto Levels performs a correction that is similar to Auto Contrast, except that it also affects the color of your image. Theoretically, this should remove any overall color cast—but if your image doesn't have an overall color cast, it might actually add one. Still, this is worth a try for images that need a little

more contrast and have an obvious color cast you want to remove.

Auto Color Correction

This is the most sophisticated of the three automatic functions—and it works remarkably well on a lot of images. While it sometimes introduces color problems, in many images it will be all you need to get the color and contrast to a point that is quite acceptable.

FOR BETTER CONTROL . . .

You can adjust the color and contrast manually using the tools found under Enhance>Adjust Color, Enhance> Adjust Lighting, and Enhance>Adjust Brightness/Contrast. Most of the tools found here can be figured out with a little trial and error. The Levels tool, however, is a bit more complex—but it's also the best tool for making really fine adjustments. For instruction on this, consult the Help files in Elements or an Elements manual (I would, of course, recommend my own book *The Beginner's Guide to Adobe® Photoshop® Elements®* [Amherst Media, 2004]).

BRUSH-BASED TOOLS

Certainly photography is an art, but with digital its ties to traditional art forms like painting have become even stronger—as witnessed by the wide use of brushes.

In the following lessons, you'll learn about some tools that require you to use brushes. Like regular paintbrushes these come in different sizes, shapes, and textures. To create precise effects, you need to select the right brush for each task.

Selecting a Brush

When you choose a tool that uses a brush, the Options bar at the top of the screen changes to include brush size and brush shape. You can also set the opacity (how transparent or opaque the effect you apply will be).

To select one of the many preset brushes, click on the rectangular box with the brush-stroke icon in it in the Options bar. At the top of the window that pops open, you can select from different types of brushes and see samples of them in the window that appears

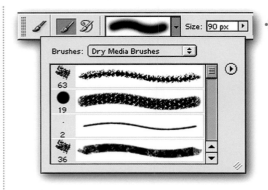

Part of the Options bar for the Brush tool.

below. To adjust the size of the brush, move to the right on the Options bar and enter a number (the larger the number, the bigger the brush). To adjust the opacity of the paint, continue to move to the right on the Options bar.

When you're done, just click and drag over your image to begin painting with the foreground color (see below).

For more choices, you can go to the Options bar and click on the tool icon next to the words "More Options." This will let you further customize your brushes by adjusting the hardness and other characteristics. Consult Elements' excellent help files for more details on these very specialized settings.

Paint Colors

Some of the brush-based tools in Elements are also for painting, airbrushing,

BRUSH-BASED TOOLS

In Elements, you'll need to select a brush when using the following tools: Brush tool, Eraser tool, Blur tool, Sponge tool, Burn tool, Dodge tool, Smudge tool, Red Eye Brush tool, and Pencil tool.

drawing, etc. When using these tools, you need to be able to specify the color of paint that you want to use. There are several ways to do this.

In Elements, you can keep your brushes loaded with two colors—the foreground and background colors. Swatches of the current setting for each appear at the bottom of the Tool bar.

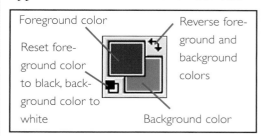

The foreground color is the color actively available for painting or drawing. When you open Elements, the foreground color will be set to black, and the background color will be set to white. However, this can be changed and set however you like.

Swatches. The easiest way to change the foreground color is to use the preset colors provided in the Swatches palette (Window>Color Swatches).

To set one of these colors as your foreground color, simpy click on the square with the color you like. To use a color from the swatches as your back-

The Swatches palette gives you easy access to a variety of commonly used colors.

The Color Picker dialog box.

ground color, hold down the Cmd/Ctrl key and click on a swatch.

Color Picker. To create a custom color, use the Color Picker. To open it, click on either the foreground or background color swatch in the Tool bar.

In the Color Picker dialog box, you will see a large window with shades of a single color. To the right is a narrow bar with the full spectrum of colors. At the top right are two swatches; at the top is the current color, and at the bottom is the original color.

To use the Color Picker, begin with the narrow bar that runs through the colors of the rainbow. Click and drag either of the sliders on the bar up and down until you see something close to the color you want in the large window. Then, in that large window, move your cursor over the color you want and click to select it. Hit OK to apply the change.

To select a second color, use the bent arrow above the color swatches in the Tool bar to reverse the foreground and background colors. This will swap your first color into the background so you can pick a new foreground color. You can reverse these as often as you want.

BLACK & WHITE

Black & white photographs are classic—and there's no reason to give up on them just because you're shooting digital. In fact, with digital, you can achieve better control than ever.

Photography began with black & white images, and their popularity has never disappeared. Often, eliminating the colors helps us get to the core of the photographer's message. Also, many people consider black & white to simply be a more flattering look for portraits. Black & white is also a classic look for landscape photography.

Shoot in Color

Here's the beauty of digital black & white: you can shoot everything in color and decide later which images might look good in black & white. This is much easier than having to switch to black & white film—and you aren't committed to shooting a full roll.

Subject Selection

When you're looking at your images and trying to decide whether a particular one might look good in black & white, look carefully at the subject. Images that make good black & white photos have subjects where the shapes are more

Both versions of this image work well, but in the black & white one, your eyes are drawn more to the receding lines of the train tracks than to the vibrant greens and blues of the sky and foliage in the color image.

The Dodge tool is used to lighten areas of your image that are too dark; the Burn tool is used to darken areas that are too light. These tools can be set to affect only one tonal range (the highlights, the midtones, or the shadows). By adjusting the Exposure setting, you can also usually control how intense the darkening or lightening effect will be. In the image on the left, the background was hazy and too light—especially when considered in comparison to the foreground. To fix this, the Burn tool was used to darken the area, balancing it better with the foreground, as seen in the photo on the right.

important than the colors. That also makes the technique good for images where part of the photo contains colors that actually distract from the main subject; by eliminating the color, you can sometimes eliminate the distraction.

Converting

There are several ways in Elements to convert an image to black & white. The easiest is just to go to Enhance>Adjust Color>Remove Color. You can also switch your image to the Grayscale color mode (Image>Mode>Grayscale). This sometimes creates a more neutral black & white result than using the Remove Color command, but you'll want to convert your image back to the RGB mode to print (Image>Mode>RGB). This won't add the colors back in but will construct the black & white tones in the way that most printers (both at home and in commercial photo labs) are set up to best handle them.

Frequently, images converted to black & white from color need a little contrast boost to make them look as crisp and engaging as the color original. You can use the Auto Contrast tool (pages 74–75) or go to Enhance>Adjust Brightness/Contrast>Brightness/Contrast to fine-tune the contrast.

In some black & white photos, you may find that there are specific areas that are too dark or too light. In this case, try using the Dodge or Burn tool. This tool imitates a traditional darkroom procedure that black & white masters like Ansel Adams employed to perfect their classic images. The images above show an example of the results achieved.

If you really like the look of old black & white photos, try adding some grain (Filter>Artistic>Film Grain).

CREATIVE COLOR

Handcoloring and toning are incredibly versatile ways to really personalize your images—and the effects can be as subtle or dramatic as you want.

Toning and handcoloring are classic photo processes. Before the invention of color photography, these were ways to add color to an image (and, in the case of toning, to make prints more resistant to fading). Today, the effects have remained popular.

Toning

The Hue/Saturation command lets you create the classic look of a toned black & white photograph. Sepia (a golden-brown tone) is the most commonly added color, but there's no reason you can't use whatever color you think makes your image look its best.

To do this, open the image you want to tone. In the Hue/Saturation dialog box (Enhance>Adjust Color>Hue/Saturation), click on the Colorize check box at the bottom right. Then, move the Hue slider until your image is the color you want it to be. To reduce or increase the intensity of the color,

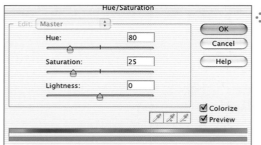

The Hue/Saturation dialog box with the Colorize box checked to tone the image.

Here, the sepia-toned version of the image seems to better convey the age and decayed state of the subject.

The original image (left) was shot in color. The background layer was then duplicated and desaturated to create a black & white image overlaying the color one (right).

The duplicate background layer was partially erased to reveal the underlying color of the dragonfly (left). For a different look, more of the duplicate layer was erased and the layer was set to 80 percent opacity to reveal a little bit of color throughout the frame (right).

use the Saturation slider. To brighten or darken the overall image, click and drag the Lightness slider.

Handcoloring

Handcoloring is a classic look, and with digital you can add it in seconds.

Begin with a color image and duplicate the background layer by dragging it onto the duplication icon at the bottom of the Layers palette.

Next, remove the color from the background copy by going to Enhance> Adjust Color>Remove Color. When you do this, the image will turn black & white—but by reducing the opacity of the new layer (at the top of the layers palette) you can allow the colors from the underlying photo to show through. Try setting the layer opacity to 80 percent for a subtly colored image.

To create a more traditional black & white handcolored image, set the opacity of the desaturated layer to 100 percent and use the Eraser tool to reveal the underlying photo. Adjust the Eraser's opacity to allow as much color to show through as you like.

In the example above, both techniques were combined to create the final image. The opacity of the duplicated background layer was set to 80 percent, then select areas were partially or completely erased to let color show through.

RED-EYE AND BLEMISHES

Red-eye is just one of those things we used to live with in a lot of images—but no more. Now you can quickly remove this annoyance and other little blemishes, too.

Professional image retouching can make a portrait subject look like a million bucks. Now the same tools pros use are at your fingertips, so you never have to live with blemishes and other little problems—even in your snapshots!

Clone Stamp Tool

The Clone Stamp tool works just like a rubber stamp, but the "ink" for the stamp is data from one good area of your image that you "stamp" over a problem area of your image. Using this tool definitely takes some practice, but once you master it, you'll probably find you use it on just about every image.

To begin, choose the Clone Stamp tool from the Tool bar. Then, set the brush size in the Options bar at the top of the screen (the size you choose will depend on the area available to sample from and the area you want to cover).

The Clone Stamp tool is perfect for removing small blemishes (left) and creating a more flawless look (right). You can even use it to remove stray hairs and shape the eyebrows! Photo by Jeff Smith.

Size: 10 px Mode: Normal Opacity: 100% ☑ Aligned ☐ Use All Layers

The Clone Stamp tool Options bar.

The Red Eye Brush can be used to remove red-eye (left) and create a much more pleasing appearance (right).

The Red Eye Brush Options bar.

Move your mouse over the area that you want to clone, then hold down the Opt/Alt key and click. Next, move your mouse over the area where you want the cloned data to appear and click (or click and drag). As with the other painting tools, you can also adjust the opacity of the Clone Stamp tool in the Options bar. Use the Zoom tool (magnifying glass) to enlarge your view for precise work.

Red Eye Brush

Red-eye is just a fact of the anatomy of our eyes, but that doesn't mean we have to live with it in our images. Elements makes it easy to remove the problem and create a much more pleasing look. For this correction, it will be very helpful to zoom in tightly on the eyes you want to correct.

To use the Red Eye Brush, choose it from the Tool bar, then select the brush settings you want. Click on Default Colors to reset the Current color to red and the Replacement Color to black. Then, make sure the Sampling is set to First Click. Position your mouse over a red area of the eye and click (or click and drag) to replace the red with a dull gray.

If the red isn't all replaced, try setting the Tolerance slider higher (the default 30-percent setting will work for almost every image, though).

CROPPING

One of the quickest ways to improve the look of many images is by cropping out areas that distract the viewer from your subject. Cropping also changes the image size, though, so it needs to be done carefully.

The Crop tool is used to remove extraneous areas from the edges of a photo. This is a great way to improve the look of photographs you didn't have time to frame carefully or ones that you just didn't compose as well as you might have liked.

To crop an image, choose the Crop tool from the Tool bar. Click and drag over the area of your image that you want to keep, then release your mouse button. You don't have to be incredibly precise. At each corner of the crop indicator (the dotted line) you will see small boxes. These are handles that you can click and drag to reshape or reposition the box. (As you get near the edges of the photo, these handles tend to "stick" to the edges. To prevent this, click on the handle you want to drag, then press and hold the Control key while moving the handle.) When the cropped area looks right, hit Enter.

Straightening Images

The Crop tool can also be used very effectively to straighten a crooked image. Simply click and drag over the

Cropping is a great way to highlight the best part an image.

Cropping is a quick way to straighten out a crooked image, but you do lose some pixels in the process.

image with the Crop tool, then position your mouse over one of the corner handles until the cursor's arrow icon turns into a bent arrow icon. Once you see this, click and rotate the crop indicator as needed. Doing this may cause the edges of the box that indicates the crop area to go outside the edges of the image. If this happens, simply click on and drag each one to reposition them inside the frame.

Crop Tool Options

In the Options bar at the top of the screen you can set the final size of the cropped image. This is helpful if, for

instance, you specifically want to create a 4"x6" print to frame. Simply enter the desired height, width, and resolution needed before cropping, then click and drag over the image to select just the area you want in your print. The Crop tool will automatically constrain itself to the desired proportions.

Also in the Options bar is a setting for the shield color and opacity. This shield obscures the area you are cropping out, giving you a better idea of what the photo will look like with these areas removed. Leaving it set to black will usually be fine, but you can change the color by clicking on the rectangle to the right of the words Shield Color. You can also adjust the opacity to allow the cropped-out area to be partially visible. To turn off the shield, uncheck the box to the left of Shield Color.

Select to Crop

You can also use any of the selection tools (see page 69) to crop an image. To do this, select any area of the image, then, with the selection still active, go to Image>Crop.

CROPPING AND RESOLUTION

Cropping reduces the total number of pixels in an image. If you are scanning an image and plan to crop it, you may therefore wish to scan your image at a higher resolution or enlargement to compensate for this reduction. If you are working with an image from a digital camera, the total number of pixels in your image is fixed, so you'll need to determine the final resolution and image size you need and not crop the image to a smaller size than that.

COMPOSITING IMAGES

All too often, an image is good except for one area that could be better. With digital imaging software at your fingertips, you can draw on other images to fix this.

The ability to seamlessly composite images (using parts from two or more images to create one final image) was one of the first big advantages of digital imaging.

Before digital, swapping heads in a portrait or changing a stormy sky to a sunny one was very time-consuming and required the creative skills of a master darkroom technician. Today, the job is much easier.

Producing totally realistic results when compositing an image still takes practice, of course. The example here is an extremely simple one, but it gives you an idea of what's involved.

A Boring Sky

In the image to the right (top), the sky lacks texture and detail. There's not much you can do about that when taking the picture. To fix the problem, the image was opened in Adobe Elements.

Selecting the Area

The first step is to select the sky area— the area we want to replace. Because the area was all pretty much the same color,

The original sky (top) was uninspiring. Selecting it (bottom) was the first step to changing it.

the Magic Wand tool was perfect for making this selection. In the Options bar at the top of the screen, the Tolerance (how similar in value the pixels must be in order to be selected) was

set to 30. The Contiguous box was also checked, ensuring that only colors in the sky area (not similar tones that happened to occur throughout the image) would be selected. Then, the sky was clicked on to select it (bottom image, facing page).

Choosing a Replacement

Bald, ugly skies are a common problem. Therefore, you might want to keep a file of images with nice skies. It doesn't matter what's in the rest of the photo; you'll only be using the sky. In this case, the sky in the whale photo (top left) seemed like a good choice.

Select the Sky

Once you've found a sky you like, use the Marquee tool to select it. Copy the selected area (Edit>Copy). Move back to your original image with the selection still active and go to Edit>Paste Into. Your new sky will appear in the selected area. If it's not positioned quite right, use the Move tool to click and drag it into place. You'll get the best results with this technique if both images are about the same size and resolution.

Blending

When the horizon line is sharp, as it is here, that's it—you're done. With other images, however, you may need to blend the new sky into its new home. This can usually be done by carefully using the Clone Stamp tool to remove any telltale edges around the perimeter of the selected area. This is basically the same technique as the one used to cover blemishes (see pages 82–83).

The sky from the whale image (top) was copied and pasted into the original photograph to create the image seen above.

VIGNETTES

Looking for a way to add a little professional polish to your images? Vignettes can improve a lot of images and give your photographs a beautifully finished look.

Vignetting is a darkening (or, in some cases, a lightening) around the edges of an image. Vignetting is used to draw the viewer's eye away from the background and toward the subject.

Dark Vignettes

Dark vignetting is the most common type and tends to be used when the overall image is normal to dark—like the image to the right. It involves darkening the corners and sides of the image, making the central portion of the frame the lightest in the photo (and therefore the part the viewer's eye will be drawn to).

The process is easy. Simply use the Elliptical Marquee tool to select the part of the photograph you want to remain unchanged (usually the center area of the image, as seen in the bottom-left photograph).

Next, go to Select>Inverse. Doing this will change your selection so that the selected area becomes everything that *wasn't* in the original selection you made (i.e., if you selected the *center* of the image, the active selection will now be the *edges* of the image).

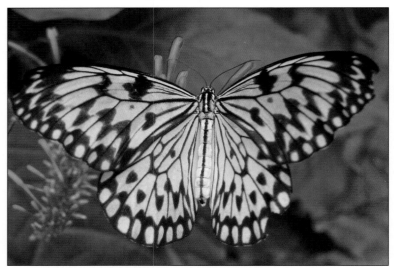

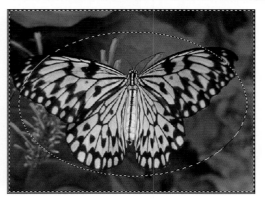

In the image above, the butterfly competes with the background. To add a vignette, the Elliptical Marquee tool was used to select the image center (left). The selection was then inversed (right).

The selection was feathered to make the edges soft and blurry (above). Then, it was filled with black at a low opacity (right).

Vignettes usually have soft, blurry edges. To accomplish this, we'll feather the selection (Select>Feather). A little experimentation may be needed to get just the look you want, but something in the 50 to 100 pixel range will usually be good for a high resolution photo (one that's 200dpi or more). Use lower settings for low-resolution images.

To complete the vignette, go to Edit>Fill. Under Contents, select Black from the Use pull-down menu. Leave the Mode set to Normal and set the Opacity to about 30 percent for a subtle effect. The result will be something like the one seen at the bottom of the page.

Light Vignettes

For a light vignette (good for images where the background is very light), follow all the same steps but choose White from the Use pulldown menu in the Fill dialog box. You will also want to set the Opacity quite a lot higher—maybe as high as 100 percent to totally wipe out the background detail.

In the final image, the darkened corners help keep your eyes focused on the butterfly and not the colorful background.

ADDING TEXT

Using the Text tool, you can add lettering in almost any imaginable shape or form to your images. So the next time you want to make an invitation or flyer, consider using Elements for a creative look.

To add text to an image, select the Text tool from the Tool bar, then set the options as you like. Click anywhere on your image and a blinking cursor will appear. Begin typing your text. When you have finished, click the "⊘" (at the far right of the Options bar) to cancel your work or the "✓" button to accept it. Selecting a new tool will automatically accept the current text. All text is automatically created on a new layer.

Options

Just as you would in a word-processing program, you have a number of options for fine-tuning your text. Accessed via the Options bar, these are (from left to right):

Font Style—Choose regular or another style (the styles available vary from font to font).

Font Family—Select the style of type (font) you wish to use from those installed on your computer.

Font Size—Select a size from the pulldown list or type in your own value.

Anti-Aliased—Smooths the curves in the letters, preventing a jagged look.

Text Styles—Lets you bold, italicize, or underline text.

WINTER

The Text tool was selected and text was added to the image.

WINTER

Using the Move tool, the text was dragged into position.

WINTER

The Confetti type effect (from the Effects palette) was added to the image, but it didn't seem right (Edit>Undo).

WINTER

The text was selected by clicking and dragging over it with the Text tool. The Text Warp was applied.

After undoing the Text Warp, the Water Reflection effect was selected for the final image.

In the top image, the word SPRING was selected using the Type Mask tool. The selected area was then copied (Edit>Copy) and pasted (Edit>Paste) into a new file (second image). It could also have been pasted into a new layer in the original leaf image or into another photo. From there, it can be customized as you would any other image layer. In the third image, a bevel was added from the Effects palette. In the final image, the Pointillize filter (Filter>Pixelate>Pointillize) was applied and a drop shadow was added.

CUSTOM SHAPES

Elements offers an array of custom shapes to add to your images—there are frames, animals, arrows, symbols, foods, and much more. To use one, select the Custom Shape tool. In the Options bar, click on the Shape menu (seen here) and pick a shape. (To see all of the available shapes, click on the arrow at the top right of this menu and select All Elements Shapes.) Choose the shape you want, then click and drag over your image. You can fill the shape with a color or do anything else you want to it.

Paragraph Justification—Controls how the lines in a paragraph are aligned (left, centered, or right).

Text Color—Sets the color of the text. Click on this box to activate the Color Picker (see page 77).

Text Warp—Allows you to create curved and otherwise distorted text. Simply select the style of warp you want, then set it to vertical or horizontal. By adjusting the bend and horizontal/vertical distortion, you can set the warp as you like.

Vertical or Horizontal Text—Allows you to select whether text runs across the page or up and down it.

Editing Text

To edit your text, select the Text tool and click on the text in your image to reactivate the cursor. You can select strings of text by clicking and dragging over the letters. You can also cut/copy and paste text by selecting it and going to Edit>Cut/Copy and Edit>Paste.

Text Effects

To add some interesting effects to your text, check out the text effects in the Effects palette (in the Palette Well).

Type Mask Tool

Sometimes the effect you want to create is better accomplished with the text as a selection rather than as editable text. To do this, go to the Tool bar and hold down on the Text tool. Then choose the Text as Mask tool and type your text on the layer where you want the selection to be active. An example of this is shown at the top left of this page.

SHARPEN OR SOFTEN

As you work toward perfecting your photos, don't neglect the impact that focus (or a little lack thereof) can have on them. Sharpening and softening are invaluable tools for fine-tuning your images.

Sharpening and blurring are everyday operations with digital images. You can use them to remedy flaws or to enhance the appearance of your subject.

Sharpening

If your image looks pretty much okay to the naked eye, but a little fuzziness is apparent when you really get critical, sharpening may do the trick. Almost every scan of an image also requires at least a little sharpening to make it look as crisp as the original.

To sharpen an image, go to Filter> Sharpen and select the tool you want to use. As noted below, some filters run automatically, while others require you to adjust their settings.

The Sharpen filter automatically applies itself to every pixel in the image or selection. It works by enhancing the contrast between adjoining pixels, creating the appearance of sharper focus. The Sharpen More filter does the same thing, but with more intensity.

The Sharpen Edges filter seeks out the edges of objects and enhances those areas to create the illusion of increased sharpness. Elements identifies edges by looking for differences in color and contrast between adjacent pixels.

Unsharp Mask is the most powerful sharpening filter in Elements. To begin, go to Filter>Sharpen>Unsharp Mask. This will bring up a dialog box in which you can adjust the Amount (how much sharpening occurs), the Radius (how far

The original image was scanned from a print and needed some sharpening.

Using the Unsharp Mask, the image was slightly sharpened.

Sharpening must be done in moderation. Oversharpened photos look grainy and have unattractive light halos around dark areas, and dark halos around light ones.

The Unsharp Mask dialog box.

from each pixel the effect is applied), and the Threshold (how similar in value the pixels must be to be sharpened). To start, try setting the Amount to 150 percent, the Radius to 2 pixels, and the Threshold to 10 levels. Watch the preview and fine-tune these settings until you like the results.

If you're not sure you've sharpened an image correctly, go to Edit>Undo and compare the new version to the original. If the sharpened version was better, you can return to it by going to Edit>Redo.

Softening

Images from digital cameras are often so sharp that they don't make your subject look its best.

To add a forgiving amount of softness, duplicate the background layer and apply the Gaussian Blur filter to it (Filter>Blur>Gaussian Blur) at a low setting (3 to 5 pixels). After applying the filter, set the blending mode of the duplicated layer to Lighten (at the top of the Layers palette).

The Gaussian Blur filter and the Blur tool (used just like the Sharpening tool, as was described above) are also very useful for improving images by making distracting elements much less noticeable.

To give a softer look to the original image (left), the background layer was duplicated, blurred, and set to lighten (right).

CHANGING SHAPES

Images can become unpleasantly distorted just because of the way our lenses bend light—with digital, it's easy to correct. You can also add a little distortion when it's called for.

Often, it's not colors or textures in our images that are the problem—it may be the shape of the subject.

Correcting Distortion

When photographing a subject with strong geometric lines, you get the best results when you keep your camera square to the subject—but sometimes this isn't feasible. For example, unless you have an extreme wide-angle lens or can shoot from far away, you normally can't keep your camera square to the subject when photographing a tall building from the ground.

IMAGE VIEW

If you can't see the edges of your image, you can reduce your view of the photograph until you can see the whole thing. To do this, type a small percentage value into the box at the lower-left edge of your image window.

This sort of distortion is such a common problem among photographers that Elements has some special tools to help fix it (and to create some other interesting effects, if you like).

To begin, go to Select>All. You will see a blinking dotted line appear around

The photo on the left was taken from slightly below and to the left of the window. As a result, the vertical and horizontal lines are all slightly skewed and the window seems distorted. Going to Image> Transform>Distort allowed the image to actually be "undistorted," resulting in a much better-looking image (right).

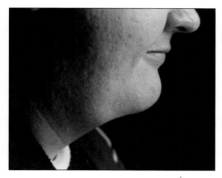
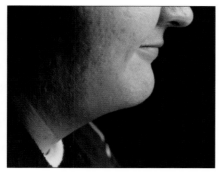

Here, the man's chin and neck area (left) were reshaped using the Liquify filter (center). Using the Burn tool, the shadows were then enhanced to further reduce the visibility of this area (right). Note that the change is subtle—people should still look like themselves after you make these little refinements. Original photo by Jeff Smith.

LIQUIFY TOOLS

- Warp
- Turbulence
- Twirl Clockwise
- Twirl Counter-clockwise
- Pucker
- Bloat
- Shift Pixels
- Reflection
- Reconstruct
- Zoom
- Hand

your entire image, indicating that the changes you make will apply to the entire image. Go to Image>Transform. When you select any of the options from this pull-down list, an indicator box with handles (the small boxes at each corner and in the centers of the sides) will appear over your image. By clicking and dragging on these handles, you will manipulate the image data within the frame of the photograph.

Hit Return to accept the changes you make. If you don't like the change, click on another tool from the Tool bar and cancel the transformation when prompted.

Liquify

Distorting small areas can eliminate figure flaws. In advertising photography, this tool is used to make a model's eyes or lips look a little bigger or more full.

The key to using the tool is subtlety. The more you distort a given area, the

LIQUIFY CONTROLS

OK — Accept or cancel the changes made in this dialog box
Cancel
Revert — Undo the distortion
Help

Tool Options
Brush Size: 64
Brush Pressure: 50 — Select the brush size and pressure for applying effects
Turbulent Jitter: 70
☐ Stylus Pressure

more likely the refinement will look fake. When using it on people, be careful not to distort your subjects so much that they don't look like themselves.

To use this filter, go to Filter>Distort>Liquify. Doing so will open a full-screen dialog box with a large preview of your image in the center and two control panels on either side. To the left of your image are the tools, and to the right are the options.

To begin, select the Warp, Turbulence, Twist, Pucker, Bloat, Shift Pixels, or Reflection tool. Then, choose a brush from the options panel. For the most impact, select a rather large brush (perhaps in the 50 to 100 range), and set the brush pressure to about 50 (higher settings will provide even more distortion). Then, by clicking and dragging over the image preview, simply begin painting on the distortion. The longer you leave your brush in one area, the more the pixels there will be distorted. Try experimenting with several of the tools, using different brush sizes and pressures, and painting quickly versus slowly.

If you like the results of your work as shown in the preview window, hit OK to accept the changes. If you don't like them but you want to try again, hit Revert.

IMAGE RESTORATION

Very few images can be fixed with only one tool. In most cases, you'll need to employ several tools, combining their functions to make the needed corrections and enhancements.

The first step when restoring an image is to make a quick visual analysis and create a to-do list of things to fix. For this image, the list included:

1. Remove small spots and specks.
2. Repair torn corner and crease.
3. Remove ink mark.
4. Improve color and contrast.

The first step was to correct the various spots and specks scattered across the photograph. To do this, the Clone Stamp tool was used to sample nearby data and copy it over the damaged areas.

Next, an undamaged area of the background that was close to the color of the missing area was selected with the Marquee tool. This was copied and pasted. Pasted image data automatically appears in a new layer, so the Move tool was used to drag the copied area over the torn edge. The missing areas were then filled in using the same method. The Clone Stamp tool was then used to disguise any edges that were visible.

The original image (left) had a torn corner, a crease, an ink mark, and some yellow discoloration. After removing some spots and specks, part of the background was copied and used to begin repairing the torn corner (right).

The crease across the image was also fixed using the Clone Stamp tool, as was the ink mark at the bottom of the photograph (as you can see, this is a pretty useful tool!). With areas like these where there is a lot of texture and image detail, it's important to zoom in and use a small brush to do your work. The areas you sample with your tool should also be selected very carefully to ensure they will blend seamlessly over the area that you want to conceal.

After fixing the crease and the ink mark, the Auto Color command (Enhance>Auto Color Correction) was used to eliminate the color cast. If you want-

ed to keep the faded sepia color, you could skip this step—or you could remove the color cast as suggested and then use the technique on pages 80–81 to add a customized toning effect.

The crease was repaired using the Clone Stamp tool. Zooming in (top left) ensured accurate corrections. After fixing the torn corner and crease, the ink mark still needed to be removed (top right). This was also done with the Clone Stamp tool (bottom left). Finally, the Auto Color Correction command was employed to remove the color cast.

Once you've shot some great images, uploaded them, and perfected each frame, it's time to share your images with friends and family—as prints, in digital albums, on t-shirts, via e-mail, on your web site . . . the list goes on and on!

HOME PRINTING

Despite the wide availability of other photo products, prints remain the most popular way to share your photos—and now you can make them at home!

Purchasing a printer for your digital images can take a bit of research—there are lots of models on the market and lots of factors to consider.

Cost

First, you'll need to consider cost—but don't look at just the cost of the printer itself. It's extremely important to check the prices, longevity, and availability of the ink cartridges. Believe it or not, these can quickly exceed the cost of the printer itself!

How Will You Use It?

You'll also want to consider how you plan to use the printer. Will you be printing photos only, or do you also need to print word-processing documents and other office materials? Photo printers provide the best results for digital images, but they can be slow (and rather expensive per page) for printing other documents.

Print Quality

Print quality is also an important consideration—but don't rely strictly on resolution ratings. For example, an inkjet printer with a 1400dpi resolution actually won't produce as good a print as a

Inkjet printers are a popular choice for printing photos at home.

dye-sublimation printer with a 300dpi resolution. Why? As you'll read below, it has to do with the way each type of printer applies color to a page.

Inkjet *vs.* Dye-Sublimation

When purchasing a home printer, most people will be choosing from two basic types: inkjet and dye-sublimation.

Inkjet printers squirt fine droplets of liquid ink onto the surface of the paper. These models tend to be inexpensive and, for most images, do a good job of producing photorealistic prints.

With inkjet printers, consider carefully the number of inks used to print images and how the ink tanks are divided up. The general rule of thumb is that

the more colors of ink you have, the better your prints will look. The minimum number you will find is four (black, cyan, magenta, and yellow), but many models feature two additional colors (a light cyan and a light magenta) that enhance color reproduction. It's also advisable to purchase a model that allows you to replace each ink color individually as they run out—this will save you money in the long run.

Keep in mind that inkjet prints don't offer the same archival qualities as traditional photographs—they *will* fade over time (many in as little as a year or two). They can also be damaged very easily by any moisture.

Dye-sublimation printers are more expensive to purchase and to operate than inkjets, but they produce prints that look and feel much more like traditional photographs.

Dye-sublimation printers use solid inks on transfer rolls or ribbons. Rather than squirting drops of liquid ink, the solid ink is rapidly heated until it becomes a gas (a process knows as sublimation, hence the name). This allows the colors to diffuse onto the surface of the paper and provides better blending for more continuous tones. As a result of this process, the prints look smoother and have sharper detail than inkjet prints.

In addition, prints produced by dye-sublimation printers are more resistant to fading, so they last longer.

SOME OTHER PRINTING-RELATED CONCERNS . . .

Archival Materials

If print longevity is an issue to you, your best bet is to seek professional printing. If you *must* print your own images, though, look for a printer that permits the use of archival inks and papers. These are more expensive, but they offer the best chance for creating a long-lived print. Of course, inkjet technology simply hasn't been around all that long, so how even "archival" prints will hold up under non-laboratory conditions remains to be seen. Keeping prints cool, dry, and out of direct sunlight will also improve longevity.

Color Laser Printers

If high volume is an issue—say, you publish an illustrated monthly newsletter for the five hundred brave folks in your skydiving club—a color laser printer (right) offers nice print quality for both text and images. These printers provide rapid printing and low per-page costs.

INKJET MEDIA

If you choose to use an inkjet printer—as most people do—you'll find the shelves well stocked with all kinds of materials for you to print your images on.

Because of their low cost and good print quality, inkjet printers are the choice of most consumers for home printing. Accordingly, manufacturers have begun producing a variety of materials that put your printer to good use.

Papers

Because inkjet printers employ liquid inks, you may find that the ink tends to soak in and reduce the vibrancy of the colors; therefore, special glossy photo-quality papers are available for use with these printers. These greatly improve the look of your images and produce prints that feel more like photos.

For projects that include both photos and text, graphic arts papers offer a smooth surface that prevents excessive ink absorption, but with a matte finish that makes text easy to read.

For letters, announcements, and more, you can save yourself some ink by using papers with preprinted borders and backgrounds. Thousands of designs are available.

Labels and Stickers

Of course you can print address labels and such—but did you know you can also use your inkjet printer to produce

Using your image-editing software, your word processor, or even specialized greeting-card software, it's easy to print customized cards for any occasion.

window clings and even bumper stickers? These can be sealed using a product called Jet Coat to prevent water damage.

Cards

Pre-sized, perforated, and scored business cards, postcards, greeting cards, and more are available at any office superstore—and even at many larger department stores. Craft and other specialty stores also carry high-end, elegant invitation kits for formal occasions (like weddings) so you can completely tailor your invitation to your event.

RESOURCES

Some specialized inkjet media can be a little tricky to track down—but these sites are good places to start.

www.paper-paper.com www.papilio.com

www.thecraftypc.com www.paperzone.com

www.mcgpaper.com www.pccrafts.com

FURTHER READING

Hall, Kay. *The Color Printer Idea Book: 40 Really Cool and Useful Projects to Make with Any Color Printer!* (No Starch, 1998).

Kryzwicki, Susan and Laurel Burden. *The Ultimate Color Printer Craft Book* (Watson-Guptill Publications, 2001).

Vosburg Hall, Carolyn. *Photo Art & Craft: 50 Projects Using Photographic Imagery* (Krause Publications, 2001).

Artistic and Creative

Beautifully textured watercolor papers are available to give your printed images an instant "painterly" feel—you can even purchase 8½"x11" sheets of inkjet canvas to print out your unique masterworks. Additional artistic paper finishes and types include metallics, vellum, and velour.

For more kid-friendly art projects, try inkjet shrink sheets—the digital version of Shrinky-Dinks. Glow-in-the-dark paper is also available for any number of interesting projects, as are inkjet temporary tattoos!

Finally, inkjet printing also lets you create embossed images. Traditionally, embossed images were made by raising the surface of the paper using a shaped template and embossing tool. With an inkjet print, you simply sprinkle embossing powder on the still-wet print, then apply heat to melt the powder into a raised design.

Fabric

Many digital photographers are familiar with printable t-shirt transfers that can be ironed onto any cotton fabric. These are lots of fun and very easy to use— just remember to use your image-editing software to reverse your image from left to right *before* printing (then, when you flip the iron-on over onto the T-shirt, the photo will come out the right way).

Believe it or not, though, you can actually print directly onto fabric as well. All you need are some 8½"x11" inkjet printer fabric sheets, available at most fabric and craft stores. These are treated with an ink fixative that protects your printed images from being spoiled by getting wet and helps them stand up to washings. Simply trim any loose threads, then load one sheet at a time into your inkjet printer. Once printed, you simply peel the paper backing off and use the fabric as you wish—in a quilt, as a patch, etc. Many people also finish their fabric prints with a UV protectant to reduce the potential for fading due to harsh light exposure.

Directions

It probably goes without saying, but it's important to follow the directions on all these projects—both to ensure success and to have a safe creative experience.

Prints made on canvas and watercolor paper have a soft, artistic feel to them.

LAB PRINTING

Home printing can be fun—but when you want images that really shine and will last a lifetime, you'll need to turn to a professional photo lab for true photographic prints.

For some images, an inkjet print is just fine—especially when you just want a cute new photo to stick on the refrigerator or on the front of a greeting card. Other images, however, require more permanence and the best possible quality. You wouldn't, for instance, want the prints in your daughter's baby album to fade before she's even out of nursery school.

Real Photos

Many people don't realize that they can get prints made from their digital files on exactly the same paper and equipment that was used to make prints of their film images. So why make the trip to the lab? There are a lot of reasons.

Print Quality. True photographic prints are created using photosensitive paper and a series of chemicals rather than inks sprayed onto regular paper. This means that the tones in the image are smooth and continuous rather than being made up of tiny dots. As a result, the prints look crisp and beautiful—and details tend to be much more sharp.

Archival Quality. The papers and processes used to create true photographic prints are time tested. Your images will still be around for your kids

and grandkids to enjoy—especially if you keep them dry and out of direct sunlight.

Ease of Use. Let's face it, printing your own images is time consuming—especially if you want multiple sets in multiple sizes. The prints from a lab are made in a variety of standard sizes and can be produced with matte or shiny surfaces depending on your preference.

Cost. Here's the kicker: in addition to lasting longer and looking better, lab prints are actually *cheaper* than prints you make yourself.

Most photo neighborhood labs will make a 4"x6" print from your digital file for somewhere in the neighborhood of thirty to fifty cents. Online labs offer more competitive prices. With many on-line labs, you can even prepurchase a

Inkjet prints, unlike lab prints, are made up of tiny dots. This pattern is revealed when the image is greatly enlarged. Compare the detail in the eyelashes in the inkjet print (left) and the lab print (right). In these fine details, you can start to see where lab prints have a real advantage.

ONLINE DIGITAL PHOTO SERVICES

www.agfa.com	www.ezprints.com	www.photoworks.com	www.walmart.com
www.aol.com	www.fujifilm.net	www.printroom.com	www.winkflash.com
www.bonusprint.com	www.hpphoto.com	www.ritzcamera.com	www.xpphoto.com
www.clarkcolor.com	www.mpix.com	www.shutterfly.com	www.yahoo.com
www.clubphoto.com	www.ophoto.com	www.smugmug.com	www.yorkphoto.com
www.dotphoto.com	www.photoaccess.com	www.togophoto.com	

quantity of prints for a flat rate and get the per-print price down very low (and you can use these credits whenever you want to print as many different images as you want).

Where to Print

Mini-Labs. Many drugstores, grocery stores, and department-store mini-labs now have the ability to make true photographic prints from your digital files—you just take in your memory card or CD and select the images and print sizes you want. In about an hour, your prints will be waiting for you.

Camera Stores. The same goes for your neighborhood camera shop—take in your disc and pick out your prints. You can expect to pay slightly more here, but you'll also have the benefit of a more experienced staff that knows how to bring the best out of every image.

Online. Online printing is very easy. The per-print costs can be very low, and the shipping charges involved are usually minimal. You will usually receive your prints about a week after you place your order.

Online labs have some other nice features as well. Most allow you to set up albums of images to share with friends. This is great for images of big events like reunions—you just upload your photos and e-mail a link to the site to your family or classmates. They can then order whatever prints they want directly from the site, so you don't have to worry about who wanted what and how to get it to them.

Many online labs also offer an assortment of borders and text you can add to your images, as well as an assortment of fun photo products that can be ordered right along with your prints. Some even have professional image retouchers available who can tackle tricky jobs you aren't prepared to do yourself.

Best of all, most online photo labs will let you try out their service for free. Typically, they provide about ten free prints when you set up a new account. You'll need to spend a couple of dollars on shipping, but you'll get a good sense for how the site works and the quality of their images.

PRINT STATIONS

Many mini-labs offer do-it-yourself print stations. The prints made at these stations are ready in just a minute or two, but they are actually created on a dye-sublimation printer (see page 99), not on a real photo printer.

OTHER PHOTO PRODUCTS

When it comes to buying photos online, prints are just the beginning! There are literally hundreds of items to pick from—everything from calendars and books, to mugs, and more!

Online labs, neighborhood mini-labs, and even many copy shops now offer photo products that go way beyond prints. These make great gifts and are another way to showcase and share your best images.

Types of Products

Calendars. Many different styles are available, but your most basic choice will be between models that have twelve photos (one for each month) and one photo (with twelve monthly tear-off sheets underneath it).

Games and Toys. Photographic jigsaw puzzles (often nicely packaged in a box that also bears your photo) are widely available. You can also purchase playing cards with your photograph printed on the back, a Rubick's cube with a different photo on each side, or even a teddy bear wearing a t-shirt with your photo on it.

Stationery. In this category there is a wide variety of choices—note cards, note pads, notebooks, post cards, stickers, envelopes, labels, Post-it® cubes, and more.

Domestic Items. Photo mugs have been available in mall kiosks for years, but how about a frosted-glass photo

Photo puzzles and mugs are quick to make and fun to share.

RESOLUTION

The following are the minimum resolution requirements for creating prints at most sites. For photo gifts, the size of the product (and the photo on it) will determine the needed resolution—so the photo needed to create a locket will be smaller than the one needed to create a mouse pad or t-shirt, for example. Check with the company you plan to order from before purchasing.

wallet print419x279 pixels	11"x14" poster . .1600x1143 pixels	
4"x6" print640x480 pixels	16"x20" poster . .1920x1536 pixels	
5"x7" print1050x750 pixels	20"x30" poster . .2272x1500 pixels	
8"x10" print1280x1024 pixels		

beer stein, or a stainless-steel photo travel mug (bound to make your daily commute a little nicer)? Other good gifts for around the house include mouse pads, fridge magnets, place mats, coasters, trivets, night lights, and more.

Textiles. Photo t-shirts (in a variety of styles and colors for everyone from infants to adults) are available at many online photo labs. Many labs also offer photos on canvas tote bags and chef's aprons. Some let you use tiny versions of a favorite image in a mosaic pattern that is applied to ties and scarves. You can also find photo pillows, purses, makeup bags, and quilts.

Jewelry. Believe it or not, you can actually have a photograph either etched or enameled onto either silver or gold. For women, there are lockets, pendants, bracelets, earrings, and more. For guys, look for key chains and tie pins.

Food. Eating *photos*? Yup. Some sites offer photo chocolate bars, cookies, lollipops, and more. Most larger grocery stores now can also print your photograph on a cake to celebrate a special occasion.

Special Effects

Many sites will also allow you to add special looks to your images before purchasing products. These may include the addition of text, fancy borders or seasonal frames, or artistic effects like an overall watercolor texture. If these interest you, look for a site that provides a good range of options.

Prices

Prices can vary quite widely on all of these items, so check out a few sites and try to determine where you'll get the best value.

Tote bags can be personalized with a fun family photo.

ON THE INTERNET

The Internet is a wonderful vehicle for sharing your images with family and friends, but it's also a great place to work on your skills and improve your images.

When preparing images for Internet viewing (such as on a web site, online photo album, etc.) or transmission (such as for an e-mail attachment), the desire for excellent quality needs to be balanced with the necessity of minimizing file sizes. After all, it won't matter how great the photo is if the people you want to see it get tired of waiting for the file to load and move on before seeing it. There are a few strategies for reducing file size that can be employed to whatever degree you see fit.

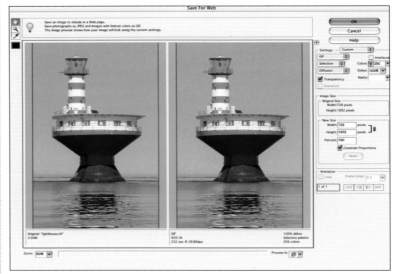

The Save for Web tool in Adobe Photoshop Elements helps you optimize your images to maximize their quality and minimize their load time.

Saving for the Internet

Color Mode. Online, most images are used in the RGB color mode (see pages 14–15). Using the Indexed Color mode, however, allows you to limit the total palette of colors used in your image, reducing the file size while retaining visual quality. At most, the Indexed Color mode allows you to use 256 colors, but you can also use fewer than 256 colors, reducing the file size and image quality in the process. The trade-off between load time and image rendition is a subjective one. If your image-editing software supports this color mode, you can experiment with the settings and your resulting file sizes; you may find a very happy medium between great color rendition and load time—especially in situations where extreme color fidelity is not required.

File Format. Saving your file in the JPG format can reduce the file size and the load time, generally without severely impacting the look of the image. For this reason, most online photo labs require your images to be in the JPG format before they will allow you to upload your files.

Optimize for the Web. Some image-editing programs offer special tools for optimizing your images for online viewing. In Abode Photoshop Elements, this is called the Save for Web

feature (File>Save for Web). With this tool, you can instantly preview your optimized image side-by-side with the original image as you adjust a number of size-reducing settings. You can also check the approximate load time for your image. The settings you choose will depend on your own preferences, but you may be surprised at how much you can reduce your file sizes while maintaining very acceptable quality.

Sharing Your Images

E-Mail. Probably the most common use for photos online is as e-mail attachments (little packages of data that are sent with a letter). These are then downloaded and opened by the recipient. This is a great way to share single photos with lots of people, since one e-mail message can be addressed to a number of recipients.

Web Page. More and more people are setting up their own web pages—a fun way to share your photos! Many Internet service providers give subscribers special tools for setting up a personal web site, so consult yours if you are interested in this option. You can also set up a free account on some web sites and receive a little space to set up your site. Most free sites offer limited storage space, but it's enough for a simple page with a few of your favorite images.

Photo Albums. Many web sites allow you to set up a free digital photo album. These are easier to use than setting up your own web site, but they don't give you quite as many options in terms of how your photos are displayed and labeled. However, many sites do offer the convenience of placing print orders right from your album. Online albums work well for sharing multiple images—say, all the photos from your birthday party or family vacation.

Expanding Your Skills

The Internet is actually a great place to refine your skills. In addition to visiting other photographers' sites and seeing how they handle their subjects, you can visit sites by both professionals and amateurs with photo tips, tutorials, and step-by-step techniques.

If you're really interested in learning, you can join a photo discussion group or community. These allow you to get feedback on your images and may even challenge the members with specific photo assignments—a great chance to compare your images of a subject with the way other photographers present it.

For more formal learning, photo courses are also available for a fee. Normally, these give you access to weekly lessons and feedback on your images from a professional photographer.

BOOST YOUR PHOTO KNOW-HOW

There are lots of photo communities and classes online. The following are homes for a few established favorites.

www.photo-seminars.com

www.betterphoto.com

www.photo.net

www.photographica.org

www.photozo.com

www.photosig.com

www.phototakers.com

www.morguefile.com

www.meetup.com

www.tribe.net

www.popularphotography.com

www.yahoo.com

MULTIMEDIA

Prints are not the only way to view your images anymore. With digital, you can use your images in a variety of ways that can make sharing them more fun and interesting for the viewers.

Along with the digital imaging revolution has come a surge in imaging technology. Swiftly dropping prices on high-speed computers and multimedia software have now made it possible for even casual shooters to put together snazzy presentations that take your home movies and photo albums to a whole new level.

Digital Albums

As noted on pages 62–63, digital album software allows you to view your images on screen in "books" complete with turning pages—some even let you create a DVD album that will play on your home theater system. Adobe Photoshop Album (www.adobe.com, $50.00) is popular, as is Flip Album (www.flipalbum.com, $20).

AV Hookups

If you prefer to bypass your computer, or don't have access to it but want to share your images with a crowd, many cameras come with a cable that allows you to hook your camera up directly to a TV through its AV ports.

On most models, you simply attach the cables and set the TV to the channel designated for AV input. Then, switch your camera to the image review mode and your photographs will appear on the TV screen instead of (or in addition to) the camera's LCD screen.

Using the image-advance buttons on the camera (or the remote control, if your camera comes with one), you can advance through the photos. In the image-review mode, your camera may also allow you to set up a slide show presentation, advancing through the images one-by-one at intervals you specify (usually 5 to 30 seconds per image).

ADDITIONAL RESOURCES

A variety of products are designed to help you use your images in multimedia presentations. Check these out:

www.microsoft.com
PowerPoint, part of Microsoft Office, is widely used to create presentations that incorporate text, sound, photos, and more.

www.macromedia.com
Macromedia is a multimedia giant with numerous professional-quality products designed for high-end work.

www.photodex.com
ProShow Gold is reasonably priced and offers lots of options for creating slide shows with special effects, music, and more.

iPhoto lets you organize and present your images in many ways.

In much the same fashion, you can record a slide show on VHS or DVD by hooking your camera up to the recorder, hitting record, and then starting the slide show on the camera (or advancing through the images manually).

Apple iPhoto

Part of the iLife suite of programs (including iMovie, iDVD, and more), iPhoto is available from Apple for under $50 (www.apple.com). It is, however, currently available only for the Macintosh operating system.

The software offers lots of interesting features for digital photographers, in addition to providing a handy way to organize your files. For example, it allows you to create a digital slide show with a musical soundtrack. You can watch this inside iPhoto or export it as a QuickTime movie so folks without iPhoto can watch it, too.

You can also use iPhoto to create a slide-show screen saver.

If you have a .Mac account, you can even instantly share your photos on the web- using HomePage, Apple's web-page publishing tool. This allows you to create a web-page gallery of your photos and send your friends the URL to view them.

More with Elements . . .

To create a slide show in Adobe Photoshop Elements, go to File>Automation Tools>PDF slide show. From the dialog box, select the images for your show, how long each remains on-screen, and how to transition between them. Under Output File, click Choose to select a name for your slide show, then hit OK. To view the slide show, use Adobe Acrobat. This may already be on your computer, or you can download it for free at www.adobe.com.

You can also go to File>Create Web Photo Gallery to instantly create a photo web page from a selection of templates.

In Adobe Photoshop Elements, you can select from a number of web-gallery templates and customize them as you like.

Secure Workflow

When you make the switch to digital, you'll find that you have a more hands-on experience with your images than you did with film. That gives you more chances to correct problems, but it also comes with more risks of messing things up.

PROTECTING IMAGES

For most nonprofessionals, the concept of an imaging workflow is brand new—but if you care about your photos, it's an important concept you'll need to master.

With digital, the image-creation process doesn't end when you click the shutter—it's just getting started! The term "workflow," therefore, is commonly used to describe everything that happens to a digital image file in the time between when it is shot and when it is output (as a print, web image, etc.) and/or archived.

Security

When you shoot digital images, your files are the equivalent of your negatives with film photography. If you lose them, damage them, or accidentally delete them, it's all over—you'll need to re-shoot the image if you want or need to use it again.

The best way to ensure that this won't happen is to develop a routine that you will use *every* time you come home with new images.

An Individual Workflow

The specific details of the process that will work for you will depend on how much you shoot, how much time you have to spend archiving your images, and how you want to use your images. The following steps will, however, be included in just about every workflow.

Upload Your Images. The first step will be to upload your images to your computer. You can do this from your camera or using a card reader—whatever works for you.

Burn a CD. Once the images are uploaded, you should immediately burn a CD (or DVD) of all of the original, unaltered image files. For the most reliable backups, choose a brand-name CD rather than the cheapest pack of 100 on the office-supply store's shelf. Five, ten, or fifteen years out, there really is a difference between the longevity of the brands.

Label the CD Clearly. Label this disc clearly, noting the date and adding a few words about the photos ("Paul's first birthday" or "Nelson family trip to Hawaii," for example). Keep in mind that, over the years, you may acquire dozens—even hundreds—of these CDs, so be specific. You may know what you mean *now* when you write "Wedding" but ten years from now you'll probably appreciate the extra effort it took to write "*Chris and Noël's* Wedding."

Also, look for pens or labels that say they are safe for use on CDs, as some products contain chemicals that can actually erode the CD.

Binders used to store music CDs also work very well for archiving discs of digital images.

sequence (which can, in turn, make it easier to track down a particular one).

Sort Your Images. The next step is to return to the images on your computer and look through them. You may want to make subfolders to separate out your favorites or to differentiate the subjects (say, if you visited the Washington Monument and Smithsonian Institute on your trip to Washington, D.C.).

Edit Your Images. Once you've decided which images you want to print or share with friends, or use on your web site, you can make any needed changes to perfect these files. Making this process a secure one is covered in the next lesson.

Test the CD. After burning this CD, test it out on your computer to ensure that it reads properly and that the image files open. If there are a lot of files, you can just test a few—unless you're really paranoid and want to try them all.

Store the CD Safely. Burning a CD at this point means that no matter what happens, you'll always be able to go back to your original image files. Given the importance of this CD, it should be stored in a secure place where it won't be exposed to moisture, excessive handling, or great heat.

If you have room, you can store your CDs in plastic jewel cases (you may even want to create labels for the cases). You can also store them in paper sleeves and place them in a sturdy box or filing cabinet. CD wallets and binders (more commonly used for music CDs) can also be very useful—especially because they make it easy to keep your image CDs in

Burn a Second CD. Editing and retouching your images requires a significant investment in time. Therefore, it's a good idea to make a second backup at this point. Consider including both your retouched and original files on this disc and storing it in a different location— maybe at work or at a friend's house. As horrible as it is to think about, in the event of a fire, flood, or other disaster, you'll be happy you made the effort.

Output. The next phase of your workflow will depend on how you want to use your images. Refer to chapter 9 for more on this.

Reformat Your Memory Card. Once you've completed this entire process, you can safely reformat your memory card and reuse it for your next pictures. Depending on how much space you have on your computer's hard drive, you can hang on to all the images there, or toss out any files you won't be needing in the near future.

SAFE ENHANCEMENTS

Sometimes we make great decisions when enhancing our images . . . sometimes, well, we don't. A few cautionary steps, however, ensure no error in judgment will be a fatal one.

You've returned home from a wedding and are thrilled to start looking though your images—especially that absolutely adorable one you took of your angelic little girl in her fancy dress holding the bride's bouquet. As you open the heart-warming shot, your little angel walks in carrying your favorite sweater . . . which she's just used to wipe up the grape juice she spilled on the living room carpet. Suddenly, the desire to augment her photograph with devil horns seems overwhelming.

Whether a part of a misguided creative endeavor or as a result of simple error, sometimes we create images that just don't say what we intended them to (or don't say it as strongly as we'd like). If you work smartly, though, digital will always give you a second chance—an opportunity to undo mistakes, reinforce assets, and, yes, even remove devil horns if need be. Here's how:

Work on Copies
As previously noted (pages 110–11), you should *never* work on your only copy of an original image. That way, you can always go back to the source if you botch an "enhancement" so badly that you need to start over from scratch.

If you're making anything but the most minor of changes, consider duplicating (File>Duplicate) the image before you start. Having a duplicate copy of the image close at hand means you won't have to track down your backup file if you need to start over again. If all goes well, toss out the duplicate.

As you work, save in-progress copies of your image—that way, even if your computer crashes you won't have to start over from scratch. Also, if you realize your recent adjustments aren't working as well as you'd planned, you can always go back to an earlier version.

Use Contact Sheets
Sometimes it can be tricky to decide if you prefer version A of an image to version B. If this happens, try printing a contact sheet of the two (or more) images you want to consider. Seeing the different versions side-by-side can make the choice more obvious.

You can also show these sheets to people and get some feedback. Often, we become so familiar with our own images that we see what we *want* to see in them; a fresh set of eyes can help bring us back to reality and promote better decision-making.

MAKING CONTACT SHEETS

With film, photographers laid their strips of negatives across photo paper and exposed them in the darkroom to create a single sheet that contained tiny versions of each image on the film. Because these prints were made with the negative in contact with the paper, they were called "contact sheets." The same idea lives on with digital—and contact sheets are still just as useful.

Most digital imaging programs will allow you to automatically make contact sheet(s) from all of the images located in one folder. In Adobe Photoshop Elements, you just go to File>Print Layouts>Contact Sheet. This will bring up the dialog box seen to the right (top). In it, you can select the folder that holds the image files you want to appear on your contact sheet. Next, choose the size of your contact sheet (if you'll be printing on 8½"x11" paper, leaving it at the default setting of 8"x10" will be fine). Set the resolution as you like, depending on whether you want to print the contact sheets or just view them on your computer monitor. Then, select how many rows and columns of images will appear on each page. The more rows and columns you choose, the smaller each thumbnail will be. Finally, choose the "Use File Name as Caption" option. As shown in the finished contact sheet (bottom right), doing this will make it much easier to find the particular image you want.

Contact sheets can be stored with backup image CDs for quick reference or used to contrast different versions of an image, as suggested on the facing page.

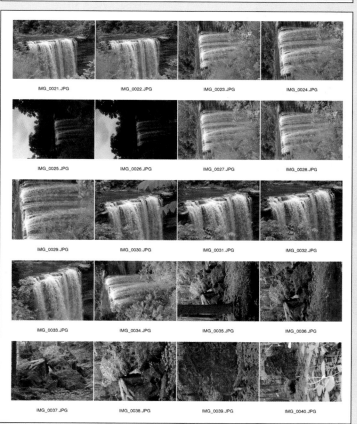

Glossary

Most of these terms will be at least somewhat familiar to you from reading this book. Others are tricky terms you may come across as you continue to explore and learn about digital imaging.

Acquire—To download or receive an image from an image-capture device such as a digital camera or scanner.

Action—A predetermined or user-determined sequence of operations that can be performed automatically by an image-editing program.

Action Shots—*See* Sports Mode.

Anti-Aliasing—Function that helps to smooth the edges of curves and prevent jagged edges.

Antistatic Brush—A device used to remove dust from slides and negatives before scanning.

Aperture—The width of the opening in the lens that light passes through to make an image. If this is wide, the scene will fall out of focus as objects within it recede from the point on which you are focused. If the aperture is narrow, more of the scene will be in sharp focus. *See* Portrait Mode *and* Landscape Mode.

Aperture Priority Mode—This mode is usually denoted by an "Av" on the exposure dial or menu. It allows you to select the aperture while the camera sets the shutter speed.

Archival Quality—The ability of a medium to resist deterioration over time. The term is often used to describe prints that are designed to resist fading and color changes.

Archive—Long-term storage of computer files.

Artistic Effects Mode—Often indicated by a palette and brush, this mode allows you to select from color options that may include shooting in black & white or sepia-tones as well as vivid color (enhanced color saturation and contrast) or neutral color (subdued color saturation and contrast).

Aspect Ratio—A comparison of the height of an image to the width of the same image. For example, a 35mm film frame is 24mm tall and 36mm wide, so the aspect ratio works out to be 1:1.5.

Attachment—A file that is sent along with an e-mail and usually requires software beyond the e-mail reader to be opened.

Auto Mode—On digital cameras, a setting where the camera makes all the decisions about exposure, focus, flash, white balance, etc. This mode is good for fast shooting under changing conditions and for inexperienced camera users.

Auto Tools—In image-editing software, tools that do not require the user to make any subjective judgments or to adjust any settings.

Batch Process—Automated process by which a user can automatically apply an action to an entire group of images.

Batteries—Digital cameras usually require rechargeable, nonstandard batteries that are designed especially for a particular model. Battery life will depend on the camera model, the battery type, how often you shoot with flash, how long you leave the LCD screen on, etc.

Bit—The fundamental unit of digital information. Each bit has only two possible values—either 1 or 0.

Bit Depth—Determines how well a scanner can differentiate between shades of colors. Today's scanners provide great results for most photos; really expensive models, however, sometimes offer even more bit depth, which can be good for high-contrast images and slides.

Blur—To reduce the apparent sharpness of an image (or area of an image).

Brightness—The overall lightness or darkness of the entire image.

Burn—(1) In film photography, to darken an area of an image by allowing more light to fall on the printing paper. In digital photography, the same effect is achieved by using the Burn tool in your image-editing software. (2) To write data to a CD or DVD.

Burst Rate—The number of images a camera can shoot in rapid sequence before it needs to pause and process the files. High burst rates are good for photographers who like to shoot fast-action subjects like sports.

Byte—A single unit of digital information; one byte contains eight bits.

Calibration—The process of matching the color and lightness characteristics of a device (like a monitor or printer) to an established standard or to a desired result.

Card Reader—A device used to read memory cards without the need to connect your digital camera to your computer. Most card readers connect via a USB or FireWire port. When buying, make sure that the reader you select is designed for the format of card you use. Some readers accept only one type; others are designed for multi-format use.

CCD—The type of image-sensor chip found in most digital cameras. These produce excellent image quality but are more expensive to manufacture than CMOS chips. *See* CMOS.

CD Burner—A device that allows you to write data onto CD-Rs (for one-time writing)

and/or CD-RWs (for multiple-session writing or rewriting). CD burners are useful for backing up and archiving your digital images.

Channel—An individual color element within a color mode. For example, an RGB image has three channels: red, green, and blue.

Close Focusing—A camera setting (usually denoted by a flower icon) that allows the lens to focus on subjects that are only a few inches from it. This setting is good for taking pictures of very small subjects.

CMOS—A type of image sensor chip found in some digital cameras—particularly digital SLRs. This type of chip has some advantages when producing really high resolution images and is less expensive to produce than CCD chips. *See* CCD.

CMYK—The color mode used for process-color printing—the type of printing that is used to create magazines, books, posters, etc.

Color Balance—The way that the colors in an image are, overall, represented. This could be accurate to the way they appeared in the scene or subject or enhanced to create a different feeling.

Color Mode—The term for the set of colors that are combined in various amounts to create all the other colors in your image.

CompactFlash—A type of memory card used by many digital cameras.

Compositing Images—In digital imaging, this is the art of combining parts of two or more photographs (or other types of images) to create one final image. The goal may be to disguise the composite (like when swapping heads between two family portraits to create one image where everyone is smiling and has their eyes open) or to create a collage effect where the combined nature of the final image is part of its message. This is also sometimes called a photomontage.

Composition—The art of carefully designing an image and consciously deciding how to frame a scene or subject. This can be done to create a more flattering view, to produce an added sense of drama, or to better tell a story or create an emotion. Well-composed images are more engaging to view than simple snapshots. *See also* Rule of Thirds.

Compressed Air—Used to remove dust from slides and negatives before scanning.

Compression—A system of arranging image data more efficiently (or removing data deemed extraneous) in order to reduce the file size.

Continuous Mode—*See* Sports Mode.

Contrast—The difference between the lightest and darkest tones within the image.

Corruption—Damage to a digital file which may make it impossible to open the file or result in the contents being garbled.

Cropping—Removing extraneous areas from the edges of a photograph.

CRT (Cathode Ray Tube) Monitor—This is the most common type of monitor today. CRT monitors are inexpensive and provide sharp, accurate images. Their curved, shiny screens can, however, make glare an issue. The large size of these monitors is another drawback.

Dead Pixels—On LCD monitors, pixels that cease to respond. If these are numerous, the effect can be very distracting and impede usage.

Dialog Box—An interactive window that, for many tools in an image-editing program, is opened on the screen when the tool is activated. The user may then adjust the performance of the tool in this window.

Distort—To change the overall shape of a selected area of image data.

Dodge—In film photography, to lighten an area of an image by preventing light from falling on the printing paper. In digital photography, the same effect is achieved by using the Dodge tool in your image-editing software.

Dot Pitch—This measurement is used to determine how sharp the display of a CRT monitor is. The smaller the number, the finer the picture. Most monitors have a dot pitch between .25mm and .28mm. On a very large monitor, a higher dot pitch (in the .30mm range) will still produce a pleasantly crisp image. *See also* CRT Monitor.

Duotone—The Duotone mode, as the name implies, is normally used to create an image that will be printed with two inks—usually black plus another non-CMYK color. This can be done in order to add the visual appeal of color without the cost of four-color printing. It can, however, also be used to add a toned look to a black & white photograph.

Dye-Sublimation Printer—A type of printer in which dry colorants are rapidly heated to a gas state then transferred to and solidified onto paper.

DVD Burner—A device that allows you to write data onto DVD-Rs (for one-time writing) and/or DVD-RWs (for multiple-session writing or rewriting). DVD burners are useful for backing up and archiving your digital images.

Feather—To blur the edges of an selected area.

File Format—The "language" in which the digital image is written. Tells an application how it should handle the data in the file to display it correctly.

File Size—The amount of memory required to store and/or process an image. The larger the file size, the more space required to store it and the more time required to perform operations on it.

Fill—To apply a color, pattern, or other data to an entire selected area.

Filter, Digital—Used within image-editing software to apply a specialized effect to an image.

Filter, Photographic—Photographic filters are pieces of glass or another transparent material that attach to the lens of a camera (or over the lens, using an accessory filter adapter) and allow you to adjust the light entering the camera in creative ways.

FireWire—A type of high-speed data transfer between peripheral devices (like card readers and external hard drives) and a computer.

Flash Memory—Memory cards that are solid state, meaning there are no moving parts (electronics rather than mechanics do the work). There are many such card formats. The CompactFlash (or CF) type is probably the most common, but Memory Stick, Secure Digital (or SD), xD, and SmartMedia are also popular. These cards have several advantages: they are lightweight, noiseless, reliable, and save images quickly. The main disadvantage is their cost.

Flattening—To eliminate individual layers by compositing them together onto the background layer.

Flip—To reverse a selected area of image data, either top to bottom (vertically) or left to right (horizontally).

Focal Length, 35mm Equivalent—Lenses function at a different *effective* focal length depending on the size of the film frame or image-sensor chip being used. Because the size of the image-sensor chips in digital cameras vary widely, manufacturers base their listings of focal length on the size of a classic 35mm film frame. If you come to digital from shooting 35mm film, this also makes it handy to choose lenses that match up with the lenses you were accustomed to using on your film camera, ensuring you'll get the focal lengths you want.

Focusing, Close—A setting on many digital point and shoots that allows you to get very close to your subject. Without this setting (usually indicated by a flower icon), you may only be able to get to within a few feet of a subject before your autofocus stops working. With the close-focus setting active, you may be able to bring your lens to within a few inches of your subject and still get a crisp, well-focused shot.

Gamut—The extent or range of colors that can be produced or displayed by a particular device (such as a monitor or printer).

Gigabyte (or GB)—A unit of data measurement equal to one thousand million bytes. The storage capacity of computer hard drives and digital camera microdrives is often described using this unit of measurement.

Gradient—A transitional blend of two or more colors.

Graphics Tablet—Used in place of a mouse, a graphics tablet allows you to move your cursor using a pen-shaped stylus—essentially allowing you to "draw." Great for digital painting and drawing, graphics tablets are also pressure sensitive—as with a real pen or paintbrush, pressing harder creates a wide, dark line; light pressure creates a thin, light line.

Grayscale—The Grayscale color mode consists of only one channel—black. You can create a quick black & white photo from a color original by switching to this mode.

Handcoloring—Adding colors (either realistic or inventive) to a black & white photograph—usually in small amounts to specific locations.

Hard Copy—A printed image (as opposed to an image viewed on screen).

Hard Drive—This is the memory used to store files and other applications that aren't in use. A big hard drive is ideal, since image files can take up lots of space. Something in the 60GB to 80GB range is ideal, but you can get away with less if you need to. External hard drives can also be added as needed.

Highlights—The lightest areas in your image.

Highlights, "Blown Out"—Highlight areas that are so overexposed that they lack any detail. *See* Metering.

Histogram—A unique graphic representation of the tones in the specific image you are working on at the moment. This can be viewed from within most image-editing software and on the LCD screens of many cameras when reviewing images.

Image Modes—On digital cameras, preset shooting options generally designed to produce good results with a particular kind of subject. These often include a sports mode (for action shots), a landscape mode (for, you guessed it, landscape images), a portrait mode (for people pictures), etc.

Image Sensor—With digital, the part of the camera that captures the image. Its unique qualities determine the resolution of the images captured on it.

Image Stitching—*See* Panoramic Images.

Image View—Controls that allow you to select the area of an image you want visible on your screen and how much (or little) it is enlarged.

Indexed Color—The Indexed Color mode allows you to limit the total number of colors in your image, reducing the file size while retaining visual quality. On web pages, where quick upload times are often much more important than color fidelity, this is a very useful format.

Inkjet Printer—A type of printer in which tiny drops of ink are squirted onto paper (or a different type of media).

Interpolation—The process of inserting extra pixels into a digital image to increase its size or resolution. This can have a serious negative impact on image quality when done in all but the smallest amounts.

Inverse—To select all of the areas in an image that were *excluded* from the base selection.

ISO Setting—On a digital camera, how sensitive to light the image sensor is set to be. At low numbers it is less sensitive and requires longer shutter speeds (or wider apertures) to create a good exposure. At high numbers it is more sensitive and requires shorter shutter speeds (or smaller apertures) to create a good exposure. The higher the ISO setting, the more noise will be seen in the image, which can reduce the image quality.

JPG—A common file format for digital images. The JPG format employs lossy compression to reduce the memory required to store images. This can result in a loss of visual quality.

Kilobyte (or KB)—A unit of data measurement equal to one thousand bytes. The memory required to store a low-resolution digital image file is often described using this term.

Landscape Mode—A shooting mode in which the camera will select the smallest practical aperture in order to keep as much as possible of the scene in focus.

Layer—In image-editing software, a discrete, transparent "sheet" of data that can be accessed, worked on, and moved without affecting other layers.

Layer Mode—Setting that determines how (if at all) the data on one layer interacts with the data on underlying layers.

LCD (Liquid Crystal Display) Monitor—Also called "flat-screen" or "studio" monitors, these models are small and light—but also pretty expensive. They do, however, provide sharp, clear images and eliminate glare problems that can be an issue with CRT monitors. *See* CRT Monitor.

LCD Screen—A screen on the back of a digital camera that is used to access menus, compose images, and review photographs.

Lens, Accessory—If your point-and-shoot camera accepts filters, you may also be able to pur-

chase a wide-angle or telephoto accessory lens to stretch the function of your built-in lens.

Lens, Fixed—Common on low-end point-and-shoot models and minicams, this type of lens offers only one view of a scene or subject.

Lens, Interchangeable—Most high-end cameras, like digital SLRs, employ lenses that can be removed and switched. You can select fixed focal-length lenses or zoom lenses, telephotos or wide-angles—whatever you want. The only drawback is that these systems can be very expensive.

Lens, Zoom—This type of lens lets you choose between several views of a scene. You can zoom in (use a telephoto setting) to get a closer view, or zoom out (use a wide-angle setting) to see a more broad view. This gives you a lot more options when it comes to composition. *See also* Zoom, Digital.

Light Meter—An instrument built into digital cameras that measures the light reflected off a subject and recommends an appropriate exposure setting. Because meters are designed for "average" scenes, they may provide misleading or less-than-optimal exposure recommendations for scenes that are very dark or very light. This can usually be corrected by using exposure compensation settings or switching to the manual mode (if available) and selecting a better exposure setting.

Link—Method by which two layers are joined together so that an action performed on one will also be performed on the other. This is also called grouping.

Macro Setting—*See* Close Focusing.

Manual Mode—On digital cameras, a setting where the photographer makes all the decisions about exposure, focus, flash, white balance, etc. This mode is good for hard-to-meter scenes and subjects, and for experienced camera users.

Mask—Indication of a selection. Instead of using dotted lines to surround the selection, the *unselected* area is covered by transparent red, indicating that this area cannot be altered.

Media Card Reader—*See* Card Reader.

Media Cards—*See* Memory Cards.

Megabyte (or MB)—A unit of data measurement equal to one million bytes. The storage capacity of digital camera memory cards, hard drives, and images is often described with this unit of measurement.

Megapixel—A measurement of the image size a particular digital camera's image sensor can capture. The number of megapixels a camera's sensor can produce is determined by multiplying the height of the sensor (in pixels) by the width and dividing by one million. For example: 1280 x 960 = 1,228,800 and 1,228,800 ÷ 1,000,000 = 1.2288. This tells us that a camera with a sensor that records 1280x960 pixels could also be said to record 1.2288 megapixels (this will normally be rounded up to 1.3 megapixels).

Memory Card Reader—*See* Card Reader.

Memory Cards—Once the image sensor has captured the photograph, it transfers the data to the memory card where it is stored. Unlike film, memory cards can also be used again and again. Although they are sometimes referred to as "digital film," memory cards don't actually record images; they just store them.

Metering—On digital cameras, metering for correct exposure works basically like it did on film cameras. However, with digital, you must meter specifically for the highlight area of the scene in order to avoid creating ugly "blown out" highlights (bright white areas with no detail).

Microdrives—A type of memory card that is actually a miniature hard drive (just like in your computer). Because microdrives feature inter-

nal moving parts, they are more delicate than flash memory cards. However, they offer much larger capacities at lower prices.

Midtones—All of the tones in an image that are neither highlights nor shadows.

Movie Mode—Most point-and-shoot models let you take short, low-resolution movies. They can also, however, eat up lots of space on your memory card, so be sure to buy a large media card if you want to shoot these regularly.

Native File Format—A file format that is associated specifically with one application program (such as a particular type of image-editing software). It is usually optimized for this program.

New—In image-editing software, to create an image file that did not originally exist.

NiCd (Nickel Cadmium)—A type of rechargeable battery. *See also* NiMH.

Night Portrait Mode—An image mode that allows you to balance a dark background with a flash-lit foreground subject.

NiMH (Nickel Metal Hydride)—A type of rechargeable battery that offers longer life and more rapid recharging than a NiCd battery. *See also* NiCd.

Noise—A grainy appearance in digital images that occurs when using high ISO settings or may be added intentionally using image-editing software to create a desired look.

Opacity—Setting that determines how much of the underlying data shows through a layer or a fill.

Open—To bring an existing image file into view in your image-editing software so that you can work on it.

Palettes—In image-editing software, free-floating windows that provide information on your image and controls for changing your image.

Panoramic Images—Long, narrow photographs that often show as much as a 360-degree view of a scene. Many digital cameras now offer a mode that helps you shoot a sequence of images that you can later combine into a single panoramic shot using software. This is often referred to as "image stitching."

Pattern—A repeated sequence of image data that can be applied as fill data.

Peripheral Device—An external device that is connected to a computer. This could include printers, scanners, external hard drives, digital camera card readers, etc.

Photomontage—*See* Compositing Images.

Pixel—Short for "picture element," a pixel is the smallest discrete part of a digital image.

Platform, Computer—The operating system a computer runs on and is designed around—for example, Windows or Macintosh. While users of one system or the other may have personal loyalties to their platform of choice, it really doesn't matter that much which one you decide to use.

Plug-ins—Plug-ins are small programs that run from within a major application like Adobe Photoshop or Adobe Photoshop Elements. Because of the prominence of Photoshop, most plug-ins are written in a Photoshop-compatible format. You don't have to use Photoshop, though; many other imaging applications (including Photoshop Elements) accept Photoshop-compatible plug-ins.

Portrait Mode—A shooting mode in which the camera will select the widest practical aperture in order to allow the area behind your subject to go quickly out of focus, making it visually less distracting.

Processing Speed, Computer—Manipulating an image requires your computer to do a lot of fancy math—so you'll want to make sure it can do so quickly. Unfortunately, getting the real low-down on this can be tricky since the methods used to calculate speed vary and make clock-speed comparisons irrelevant. The best

approach is to check out the software you want to run and make sure the computer you own (or plan to buy) has sufficient speed. Most current systems are more than adequate.

Program Mode—The program mode (usually indicated by a "P") allows you to control some settings (like white balance, ISO, etc.) but not as many as the fully manual mode.

PSD—A file format used by Abode Photoshop Elements to save images without flattening any layers that are included.

RAM—This is the memory your software and images are loaded into when you open them. If you have too little, things will get really slow. Check your software to determine its minimum requirements—and add more RAM if you need to.

Rasterize—Some artwork (such as text) is made up of lines drawn according to mathematical equations. Rasterizing causes these lines to be converted into dots (pixels).

Red-Eye Reduction—Red-eye occurs when the lens and light source (usually an on-camera flash) are directly in line with the subject's eyes. There are two ways to combat this effect. (1) Most cameras now include a red-eye reduction setting. When this setting is used, an initial burst of light closes down the pupil, preventing the second burst of light from reflecting off the retina and back into the camera (which is what makes the center of the eye look red). (2) If red-eye still occurs, you can fix it easily in your image-editing software.

Refresh Rate—On monitors, high refresh rates help reduce screen flicker, which in turn reduces eye strain and (in some people) headaches.

Remote Control—Some digital cameras come with a remote control that lets you stay in front of the camera and shoot as many images as you want. The remote may also be used to advance photos when connecting the camera to a television for a digital slide show.

Resolution, Image—How close together the pixels (dots) in an image are. Expressed as dpi (dots per inch).

Resolution, Monitor—For monitors, resolution is expressed in terms of pixels and lines—for example, a 640x480 monitor displays 480 lines of 640 pixels. Virtually all monitors can support 640x480 pixel resolution (also called "VGA" resolution). In order to display more information on screen, most models also offer at least one "Super VGA" setting—often 800x600 or 1600x1280 pixels. Some monitors offer settings at even higher resolutions.

Resolution, Optical—On a scanner, how much data can be recorded by the image sensor itself. Other, larger figures may be listed, but these values are obtained by using software to enlarge the file; this reduces the quality of the scanned image.

Retouching—Using image-editing software to reduce or correct problems in an image that were unnoticed or impossible to correct at the time the image was taken.

Revert—To return to a previously saved version of an image or to an earlier state of that image.

RGB—The color mode in which scanners, digital cameras, and monitors—devices that receive or transmit light—all capture or display color.

Rotate—To turn a selected area of image data (or the entire image) around a fixed point.

Rule of Thirds—A guideline for composition designed to help photographers place subjects in the frame to maximum advantage. By this rule, a tic-tac-toe grid of lines is mentally placed over the whole frame. The intersections of these imaginary lines are generally the best places to position the center of interest in a photograph.

Save—To preserve an image for future use (including further editing, viewing, and/or use in another application).

Scale—To change the size of a selected area of image data.

Scanner, Flatbed—Device used to digitize photographic prints and other flat, reflective surfaces. With the image in place, an image sensor with a light unit attached to it moves beneath the glass and "reads" the photograph. Electronics then translate the data from the sensors into an image. (Some flatbed-type scanners can digitize both prints *and* transparent media. These look like flatbeds but also have a built-in adapter to hold slides and film as well as a light to shine through these media onto the image sensor.)

Scanner, Transparency—Transparency scanners are more expensive than flatbed scanners. But, because slides and negatives hold image detail better than prints, they also offer better quality. Both types of scanners work in much the same way—but with a transparency scanner, the light source is on one side of the film or slide and the image sensor is on the other (i.e. the light shines *through* the film and hits the sensor).

Selections—In image-editing software, the selection tools allow you to isolate individual areas that need work and apply your changes to only those areas.

Shadows—The darkest areas in your image.

Sharpen—To increase the apparent focus of an image (or area of an image) to enhance the clear reproduction of image detail.

Shutter Lag—A delay between when you pushed the shutter button on a digital camera and when the photo is actually taken. Significant delays were a big problem with early digital cameras, which made it really hard to take action shots! Today's cameras are a lot better, but there's usually still a tiny delay.

Shutter Priority Mode—In this mode (indicated commonly by "Tv"), you select the shutter speed and the camera selects the best aperture setting to match the brightness of the scene. Choose a short shutter speed to freeze moving subjects, or a long one to blur them.

Shutter Speed—How long the camera's shutter remains open to make an exposure. When you (or your camera) choose a long shutter speed, subjects in motion will be blurred in your image; when you choose a short shutter speed, subjects in motion with be frozen in your image.

Sports Mode—When you use this mode (sometimes also called a burst or action mode), your camera will keep taking images for as long as you hold down the shutter button. This will continue until either your memory card runs out of storage space or your camera runs out of processing memory and has to pause before shooting the next image). On some models, choosing this setting will automatically switch the camera to a lower resolution setting or a higher compression setting. This makes the files smaller so that more images can be processed but may leave you with too few pixels to make the size print you want of your best image.

Stroke—The creation of a geometric line surrounding a selection.

Super VGA—A monitor setting designed to display more information on screen. Most monitors now offer at least one Super VGA setting—often 800x600 or 1600x1280 pixels. High-end monitors offer settings at even higher resolutions.

Thumbnail—A small preview of an image designed to load quickly on screen so that you can quickly scan a series of images. Clicking on the thumbnail usually opens a larger version of the image.

TIF—A common file format for digital images. The TIF format employs lossless compression to reduce the memory required to store images. This preserves the visual quality of the image.

Timer—Like most point-and-shoot film cameras, your digital will probably have a timer that allows you to set the camera and then duck into the shot. *See also* Remote Control.

Toning—Adding an overall wash of color—often a golden brown color called "sepia"—to a black & white photograph.

USB—A type of high-speed data transfer between peripheral devices (like card readers and external hard drives) and a computer.

VGA—This is the lowest monitor resolution currently used (640x480 pixel resolution). It's available on all newer monitors.

Viewable Area—With CRT models, a "17" monitor" may actually offer a viewable area that is one to two inches smaller. Most specifications for monitors list the viewable area, so look for this listing.

Viewfinder—With digital cameras, a window (like on a traditional film camera) that can be used to compose images with the camera held up to your eye.

Vignette—Darkening the edges of an image in order to draw the viewer's eye to a more centrally located subject or scene. In some cases (usually images with extremely light backgrounds), lightening the edges of the photograph can create the same effect.

White Balance Settings—With digital cameras, settings designed to balance the colors in a scene for accuracy under just about any kind of light—sunlight, fluorescent light, tungsten light, etc. Most cameras now offer automatic white balance settings and custom white balance settings in addition to a selection of presets for common lighting situations.

Workflow—An individualized procedure followed when uploading, backing up, editing, and archiving images. This is designed to safely and efficiently process digital files.

Zoom, Digital—On a digital camera, this is image enlargement that is provided by software rather than the lens. This reduces the image quality and should usually be avoided. *See also* Lens, Zoom *and* Zoom, optical.

Zoom, Optical—On a digital camera, this is image enlargement that is provided by the mechanical qualities of the lens. This produces sharp images. *See also* Lens, Zoom *and* Zoom, digital.

Index

By the Same Author . . .

TRADITIONAL PHOTO-GRAPHIC EFFECTS WITH ADOBE® PHOTOSHOP®, 2nd Ed.

Use Photoshop to enhance your photos with handcoloring, vignettes, soft focus, and much more. Step-by-step instructions are included for each technique for easy learning. $29.95 list, 8½x11, 128p, 150 color images, order no. 1721.

BEGINNER'S GUIDE TO ADOBE® PHOTOSHOP®, 2nd Ed.

Learn to effectively make your images look their best, create original artwork, or add unique effects to any image. Topics are presented in short, easy-to-digest sections that will boost confidence and ensure outstanding images. $29.95 list, 8½x11, 128p, 300 color images, order no. 1732.

COLOR CORRECTION AND ENHANCEMENT WITH ADOBE® PHOTOSHOP®

Master the precision color correction and artistic color enhancement techniques needed to perfect all of your scanned and digital-camera photos. $29.95 list, 8½x11, 128p, 300 color images, index, order no. 1776.

BEGINNER'S GUIDE TO ADOBE® PHOTOSHOP® ELEMENTS®

Packed with easy lessons for improving virtually every aspect of your images—from color balance, to creative effects, and more. $29.95 list, 8½x11, 128p, 300 color images, index, order no. 1790.

DIGITAL LANDSCAPE PHOTOGRAPHY STEP BY STEP

Digital cameras make it fun to learn landscape photography. Short, easy lessons ensure rapid learning and success! $17.95 list, 9x9, 112p, 120 color images, index, order no. 1800.

THE MASTER GUIDE TO DIGITAL SLR CAMERAS

Stan Sholik and Ron Eggers

What makes a digital SLR the right one for you? What features are available? What should you look out for? These questions and more are answered in this helpful guide. $29.95 list, 8½x11, 128p, 180 color photos, index, order no. 1791.

PLUG-INS FOR ADOBE® PHOTOSHOP®

A GUIDE FOR PHOTOGRAPHERS

Jack and Sue Drafahl

Supercharge your creativity and mastery over your photography with Photoshop and the tools outlined in this book. $29.95 list, 8½x11, 128p, 175 color photos, index, order no. 1781.

OUTDOOR AND LOCATION PORTRAIT PHOTOGRAPHY, 2nd Ed.

Jeff Smith

Learn to work with natural light, select locations, and make clients look their best. Packed with step-by-step discussions and illustrations to help you shoot like a pro! $29.95 list, 8½x11, 128p, 80 color photos, index, order no. 1632.

PHOTO RETOUCHING WITH ADOBE® PHOTOSHOP®, 2nd Ed.

Gwen Lute

Teaches every phase of the process, from scanning to final output. Learn to restore damaged photos, correct imperfections, create realistic composite images, and correct for dazzling color. $29.95 list, 8½x11, 120p, 100 color images, order no. 1660.

MASTER POSING GUIDE FOR PORTRAIT PHOTOGRAPHERS

J. D. Wacker

Learn the techniques you need to pose single portrait subjects, couples, and groups for studio or location portraits. Includes techniques for photographing weddings, teams, children, special events, and much more. $29.95 list, 8½x11, 128p, 80 photos, order no. 1722.